T0119606

The Owls Are Not
What They Seem

Forerunners: Ideas First

Short books of thought-in-process scholarship, where intense analysis, questioning, and speculation take the lead

FROM THE UNIVERSITY OF MINNESOTA PRESS

(Continued on page 95)

The Owls Are Not What They Seem

Artist as Ethologist

Arnaud Gerspacher

University of Minnesota Press

MINNEAPOLIS

LONDON

Copyright 2022 by Arnaud Gerspacher

All rights reserved. No part of this publication may be reproduced, stored in a retrieval system, or transmitted, in any form or by any means, electronic, mechanical, photocopying, recording, or otherwise, without the prior written permission of the publisher.

ISBN 978-1-5179-1356-4 (PB)
ISBN 978-1-4529-6739-4 (Ebook)
ISBN 978-1-4529-6816-2 (Manifold)

Published by the University of Minnesota Press
111 Third Avenue South, Suite 290
Minneapolis, MN 55401-2520
http://www.upress.umn.edu

Available as a Manifold edition at manifold.umn.edu

The University of Minnesota is an equal-opportunity educator and employer.

In memory of Martin Roth (1977–2019)

Contents

Preface

AN OWL IS AN OWL IS AN OWL—but only in the assembly lines of our minds. The title of this book recalls a mysterious phrase from David Lynch's *Twin Peaks* and the carnivorous birds that haunt the show by way of decorative lamps and bibelots, as well as flesh-and-blood "actors" who appear to play the role of forest intercessors between the town and the Black Lodge (fan websites exist devoted solely to the many owls in this television series). By making these sometimes nocturnal creatures fetishistically strange, Lynch refuses traditional or commonsense projections that come ready-made with these sentient-minded beings. Yet owls are neither the malevolent incarnation of BOB, nor the eminent wisdom of Minerva, nor harbingers of death, nor symbols of wealth, nor the talons of AI love (see the incredible owl scene from *Her* [2013], which might be a nice callback to the owl in *Blade Runner* [1982]), nor reducible to the taxonomic order Strigiformes, nor even simply "owls." They might be all these things in our histories of human culture, art, politics, science, and language, but not in the creaturely real—that nonnegotiable horizon and ground of what we understand emoting, thinking, communicating forms of life to be, of which we humans are only one (and usually our own favorite) example.

How can we sneak up on these speculative creatures that subtend, come before, but also, in some sense, only come to be actualized as we know them in human cultures, arts, politics, sciences, and

languages? This question echoes the correlationist conundrums in Continental philosophy and the more recent speculative endeavors of thinking the nonhuman real. In this case, however, we are part and parcel of what we are trying to catch up to or entrap. We are one of these roaming creatures, in mind and body, along the orders of animality thrown together on this planet by the pure contingency of its evo-existential unfoldings (those who would say this preface is a performative contradiction through a practice no other creature has been able to develop have [1] a limited notion of what writing is and [2] one foot inside the immanent circle of evolutionary processes and one foot outside in a groundless metaphysics of self-endowed human exceptionalism). When Nietzsche called us winged insects gathering honey-knowledge for the home, thereby remaining strangers to ourselves, since home is already where the creaturely heart is, I like to think he was calling out not only farsighted humanist knowledge making but also, more specifically, ethological knowledge (a discipline that had yet to be named and was only getting off the ground as a practice in the late nineteenth century). From this vantage point, it is clear why Nietzsche proved important for the following century's phenomenologists—and even if these philosophers have not always been amenable to nonhuman corporeality and mindedness, nothing keeps us from reading their philosophical approach as a history of animality without knowing or fully avowing it.

Alongside such philosophical practices, I maintain the need for science and art, and in such a way that they are mutually self-correcting. The positivist killjoys will have to loosen up and realize that the entities and modalities that evade the scientism of their disciplinary nets are not therefore mere pseudo-objects fit for the dustbins of New Age speculation. For their turn, aesthetic practices will have to remain vigilant of jejuneness, of the trivial instrumentally interesting, and of its institutional constraints that today more and more tend toward moneyed crassness, lifestylizations, and show. In a sense, scientists will have to think more like artists, and artists will have to think more like killjoys. Chris Marker—an artist as ethol-

ogist if there ever was one—has a short work called *An Owl Is an Owl Is an Owl* from his *Bestiaries* (1985–90) videos. Over a robotic soundtrack and voice that repeats the eponymous phrase, Marker's camera dwells on sundry owls in cages, plumed heads swiveling with smoothness and at angles that seem impossible, with massive eyes that often stare right at the viewer. Marker forces us into an ethological position of observing another life-form in the only way we can: through our own eyes and ways of being. Since the birds are not presented within the genre of some "nature" show lulling the viewer in wilderness spectacle, but instead defamiliarized via the incessant visual repetition of the camera and the eerie soundtrack, we start to get a glimpse beyond the baggage of our human cultures, arts, politics, sciences, and languages. Quite simply, the work makes us think, yes, these are owls, but what exactly is an "owl" anyway? From this moment of deconditioning, a space for speculation opens up—and if there is a central claim in my present tract, it is that philosophy, ethology, and art need each other when speculating on animality and other minds.

Another key claim: we are always both analogous and homologous with other creatures—always embedded and embodied in both a creaturely constellation and a continuum. In other words, we exist in variegated superimpositions whereby other minds and bodies are both bridges and abysses (sometime more abyss than bridge, but never fully abyssal). And yet, however interesting it is to speculate on other animals, the time comes when we need to risk entering into concrete solidarities. In the so-called Anthropocene, the sixth mass extinction, and our age of accelerating environmental destruction through, in part, the exploitation and extraction of animal bodies on a nightmarish scale, this is such a time. Going somewhat against the grain of Derridean ethics (Derrida nonetheless looms large in my thinking), whereby one is most irresponsible when one thinks oneself responsible, I maintain the need for brazen responsibility in the face of other animals and the violence relentlessly inflicted on them—or perhaps better, aspiring to be responsibly irresponsibly responsible. This has become a necessary practical and theoret-

ical gamble for ethical and ecopolitical care in these urgent and obscene times. With apologies to both Lynch fans and owl lovers, neither makes another appearance in this book. I hope the reader will nonetheless continue on and meet a slew of different animals in art history that implicate aesthetics, philosophy, and science in polemical though ultimately constructive ways.

Introduction: Some Donkeys, a Stuffed Monkey, and the Animal Factishe

LOLO WAS A DONKEY who lived at the café Le Lapin Agile in Montmartre and was a favorite nonhuman of its avant-garde clientele. He is remembered today for his role in an art world hoax generated by the artist and writer Roland Dorgelès. With fake manifesto and equally fake artist named Boronali, Dorgelès submitted and successfully exhibited the painting *Sunset over the Adriatic* at the 1910 Salon des Indépendants. Boronali was none other than Lola, who, with paintbrush attached to tail, had been coaxed into painterly gestures by way of a tasty array of vegetables.[1] This pantomimic episode resonated in avant-garde circles, and as George Baker tells it, from one tail to another, inspired Picabia's painting *Nature mortes* (1920), featuring a toy monkey affixed to cardboard.[2] Picabia's original plan was to procure a real monkey. It was only once this proved impossible that he resorted to the stuffed animal from the store.

1. See Daniel Grojnowski, "L'ane qui peint avec sa queue: Boronali au Salon des indépendants, 1910," *Actes de la recherche en sciences sociales* 88 (1991): 41–47.
2. George Baker, *Artwork Caught by the Tail: Francis Picabia and Dada in Paris* (Cambridge, Mass.: MIT Press, 2010).

With this echo from living donkey to stuffed monkey, we have, on one side, a delegated performance, which would not yet have been deemed a viable work of art, just a joke, and on the other, an animal readymade, which was all the more readymade for Picabia's inability to retrieve an actual primate.[3] The doubled irony of Picabia's failure not only renders the title cheekily senseless (something that never lived cannot be dead) but, as a generalizable commodity object, the toy fulfills Marcel Duchamp's criteria for the readymade as a freely chosen, mass-produced object with no initial auratic uniqueness far more than a dead primate. With nearly a century since the advent of modern ethology, and certainly since the advances in cognitive ethology and primatology of recent decades, it is more and more evident that monkeys are singular beings with nonhuman forms of selfhood, memory, and personality.[4] These breakthroughs in ethological knowledge, which fundamentally alter what "animal" even means, extend to primates as a whole, mammals more broadly, as well as many birds and ocean denizens, notably cetaceans and cephalopods. New knowledge keeps coming in across the animal kingdom.[5] In other words, animals can be captured, bred, and now even cloned, but never reproduced tautologically, for even genetically identical creatures will enter into the differentiations of ecological context and embodied plasticity as their lives unfold. This is the paradox of the animal readymade and what Roland Barthes called, in another context, "the impossible science of a unique being."[6] Admittedly, it is only recently that the French legal system

3. Interestingly, Baker is clear that Picabia's other impetus for *Nature mortes* was none other than the most famous readymade: Marcel Duchamp's *Fountain*, 1917.

4. See Claudio Carere and Dario Maestripieri, *Animal Personalities: Behavior, Physiology, and Evolution* (Chicago: University of Chicago Press, 2013).

5. Truth be told, we are still in the early stages of deep ethological knowledge.

6. Roland Barthes, *Camera Lucida: Reflections on Photography,* trans. Richard Howard (New York: Hill and Wang, 1981), 71. For a fuller theo-

has updated its Napoleonic civil code by decreeing that, as sentient beings, nonhuman animals exceed the status of furniture. So in twentieth-century Paris, at least from a juridico-ontological perspective, nothing would have distinguished a bottle rack from a monkey or a urinal from a donkey.

Neither Dorgelès nor Picabia had any real interest in animals beyond their role in sending up bourgeois culture, helped along by traditional associations of asses and apings. This is to say that neither Dorgelès nor Picabia was ethologically minded, which would entail making work having to do with an animal's actual being and behaviors. The same goes for, say, Buñuel and Dalí's rotting donkeys on pianos in *Un chien andalou* (1929). While successful as juxta-poetic shock aesthetics, they have very little to do with understanding donkeys or animality more broadly. This may not be the case with every surrealist, however, and it is suggestive that this well-trodden avant-garde movement developed at much the same time the disciplinary formation of modern ethology was itself getting off the ground through the 1920s and 1930s. Incipient ethological impulses in Surrealism might be found, the likes of Jean Painvelé and Paul Éluard coming to mind.[7]

As my opening comparison shows, incorporating nonhuman animals into art is part of the deregulative trajectory of twentieth-century Western avant-gardes—from readymades to found objects, performers, collaborators, processes, and bioexperiments. At times, these developments reflect a Pygmalion impulse for something more living than traditional media and a desire for the real.[8] For

rization of the animal readymade, see my dissertation chapter "Marcel Broodthaers and the Animal Readymade" in "Posthumanist Animals in Art: France and Belgium 1972–87," PhD diss., City University of New York, 2017, 158–211.

7. See the special issue "Surrealism, Ethnography, and the Animal-Human" edited by Katherine Conely, *Symposium* 67, no. 1 (2013).

8. For a canonical exploration of this impulse, see Hal Foster, *The Return of the Real: The Avant-Garde at the End of the Century* (Cambridge, Mass.: MIT Press, 1996).

some artists, involving animals serves a default flat ontology, in which all materials are equally available. Recall Allan Kaprow's list of objects fit for happenings that includes a "dog" among paint, neon lights, water, old socks, and "a thousand other things."[9] Ethological engagement is of no concern here; the animal is just a mundane object for aesthetic or anti-aesthetic uses. For other artists, it seems there is something uniquely potent about the nonhuman body, properties exploited for disparate ends, as in Vienna Aktionism's atavistic rituals with animal bodies, organs, and blood or Damien Hirst's more recent spectacularities belonging to a retrograde aesthetics of natural history and zoology—what might aptly be called necroaesthetics.[10] If here the animal is treated as a special entity, these practices are also patently nonethological instrumentalizations. For some select artists, however, nonhuman animals have proven to be of interest in their own right, from which ethological attention opens onto a multitude of novel zoopoetic and zoopolitical engagements. Joseph Beuys, though not wanting in atavism in his shamanistic handling of hares, coyotes, and all manner of creatures, is typically cited as an important progenitor of this tendency. It is to these artists that this book attends.

By framing this recent history of art and animals in such a way, something interesting happens. We are sent back to worn questions about modernism and medium specificity. In making ethology the dividing line, we have on one side nonethological practices that are effectively *pre*-modern, in the sense that they have no awareness of the scientific breakthroughs concerning animality and assume dogmatic and historically obsolete (though still culturally powerful) conceptions of animals drenched in tropes and fables. On

9. Allan Kaprow, "The Legacy of Jackson Pollock," in *Essays on the Blurring of Art and Life,* ed. Jeff Kelley (Berkeley: University of California Press, 2003), 9.

10. Anna-Sophie Springer and Etienne Turpin, "Compensatory Postures: On Natural History, Necroaesthetics, and Humiliation," in *Theater, Garden, Bestiary: A Materialist History of Exhibitions,* ed. Tristan Garcia and Vincent Normand, 161–72 (Berlin: ECAL/University of Art and Design Lausanne and Sternberg Press, 2019).

the other side, we have art practices that *do* reflect an ethological interest in animality and therefore *are* modern in their internalization of novel understandings of nonhuman animal life coming to us from scientific observation. This holds real implications for both formalist art modernism and the historic avant-gardes. For the standard reading of art modernism, a la Clement Greenberg, it is one thing to know the conditions of possibility for painting—paint, flatness, opticality, and so on—but quite another when it comes to a complex creaturely organism. In what sense can an artist be true to her materials, or have medium specificity, when the entity being incorporated is completely misunderstood? It is easy to see why art modernism limited its competence to purportedly disinterested and autonomous aesthetic experiences of traditional mediums, which prove far more easily tractable. As for the historic avant-gardes, which broadly speaking sought to facilitate the collapse of art and life, what happens to its paradigm when the inclusion of nonhuman life is equally based on misrecognition and ignorance? Perhaps this is why the now canonical advent of the postmedium condition in the 1960s and 1970s, which represents a continuation of the historic avant-gardes and a repudiation of formalist reductivism, saw a precipitous rise of animal bodies in art. Yet, unlike scientific modernism—which, if it had not restricted its preoccupation with Kantian conditions of possibility to traditional and inert materials like paint, might have opened the door to a better understanding of the living—the deregulatory impulses of the postmedium condition by and large incorporated nonhuman animals without any real knowledge of their bodies and minds. So, on one side, we have a scientifically minded conception of modern art that cannot venture too far enough away from the human eye and its official mediums, while on the other, we have a more liberatory aesthetic or anti-aesthetic realm that does not, for the most part, understand the creaturely preconditions of life, even when creatures have been involved in its practices.

Artists who remain unaware of ethological knowledge have an ideological blind spot when it comes to animality. Many modern and

contemporary philosophers share this blind spot and have similar trouble updating their thinking. This is a situation of not only *they know not what they do* but equally of *they know not what they have*. In the case of artists, it might be said that this is simply antimodernist. In some cases, this is probably true.[11] But premodern is a much better way to describe nonatavistic practices and discourses that nevertheless assume atavistic conceptions of animality. Even Futurism, for all its technoliquidations of the past, comes back time and again to historically clichéd figures of animality (reread Marinetti's 1909 "Futurist Manifesto" and encounter a snorting bestiary of horses, lions, dogs, sharks, and serpents). What I am laying out, however, is not some diachronic progression, for many contemporary artists remain similarly premodern in their understanding and usage of animals. Lola was not born at a time when animals could be featured in art installations. This had to wait for the latter half of the twentieth century—for example, Maurizio Cattelan's *Warning! Enter at your own risk. Do not touch, do not feed, no smoking, no photographs, no dogs, thank you* (1994), which was restaged at Frieze Projects in 2016. The installation is simplistic, which tends to be the case with living animal subjects in art, whose very appearance is assumed to be enough for novel art world experiences. The donkey, Sir Gabriel, was confined to a white cube filled with grass and hay under an ornate chandelier. It is not that he was overtly mistreated, or that his preferences were not fully recognized in this context (though they likely were not), or that his labor was simply taken as a given.[12]

11. Carolee Schneemann's *Meat Joy* (1964) and the aforementioned ritualistic performances of the Vienna Aktionists come to mind—though note the paleo-Dionysian lack of awareness or even disingenuousness of using bodies likely procured from very modern industrial foodways.

12. It is possible that the experience was benign, and as the organizers were quick to point out, that he is acclimated to performing and has a pretty good life. This sentiment commits two mutually reinforcing faults: that the donkey is a natural-born performer and that his use is legitimized by a fallacy of relative privation, which is often nothing more than argumentative blackmail, i.e., that he has it better than most animals.

The real point is that the installation offers nothing new about its performer, who, after all, is the central point of interest. We breathe in the stale air of novelty, along with ethological ignorance, which are only afforded by a rather unreflective sense of entitlement on the part of the artist and likely much of the audience. This posture has become especially untenable in the Anthropocene, from which anthrosovereignty has increasingly come under deserved scrutiny. It also reflects a tired humanism more generally.

These issues even crop up in more thoughtful works than Cattelan's. Marina Abramovic's *Confession* (2010) is a performance with yet another donkey in a gallery.[13] The artist kneels before the unmoving creature in a nondescript white room. With no audio, the viewer is instead presented with scrolling text of the artist's inner monologue recollecting tumultuous and often dark childhood memories. *Confession* holds a subtle ecofeminist critique in its marriage of an animal and the dysmorphic struggles of a young girl dealing with her appearance and fraught domestic life—girls and donkeys both having preconceived notions and constraints thrust upon them from birth. Abramovic recalls the pejorative nickname "giraffe" given to her by fellow teasing schoolmates. Moreover, as one of the more confrontational performance artists, Abramovic knows what it means for a living being to be reduced to an object, something an ecofeminist attuned to species would say many nonhumans also understand in different ways.[14] And yet, this performance is also not quite ethological. The animal was likely chosen for its beast of burden symbolism—as fabular trope

13. Thanks to Sean Kelly Gallery and Marina Abramovic's studio for the partial viewing copy.

14. Abramovic often cites her 1974 performance *Rhythm O* as a frightening experience in which she was reduced to a pure object manipulable by the audience. Carol J. Adams, a prominent ecofeminist and animal rights scholar, would point out that Abramovic's self-objectification, which explicitly absolved the public from any wrongdoing during the performance, finds an uncanny echo in the ways animals and women are advertised to appear as sanctioning their own carnal capture, consumption, and exploitation.

grounded in histories of labor and toil. The performance might even be charged with artistic narcissism, since the donkey appears to be nothing more than a foil for one-way autobiography. The question is never posed: What about the donkey's biography? Can nonhuman animals even be autobiographical?[15]

As a multispecies performance documented on video, *Confession* forces viewers to choose: read the text that runs at the bottom of the moving image; look at Abramovic, whose expressionless pose offers much less information than the text; or look at the donkey, who also stands largely motionless. The limits of human perception preclude doing all three at once. Most viewers will presumably focus on the text since it provides a tangible narrative, but nothing stops us from focusing on the donkey, for which ethological grounding proves essential. What does it mean for a donkey to remain still and silent like this? Are subtle gestures more meaningful than we know? What about the fact that, along with primates—*Homo sapiens* included—equines have some of the most expressive facial muscles on the planet, as cataloged by the Equine Facial Action Coding System?[16] Why is it that donkeys make such excellent therapy animals? And what to make of those markings on his body that look like lacerations? For all this, the art historian will need to be equipped with "ethograms," an iconography of the living used by ethologists, along with, ideally, firsthand knowledge of donkeys in empirical fieldwork.

A recent theater piece moves us toward what such an ethologically attentive work might look like. *Balthazar* (2011–15) was a research project by the theater director David Weber-Krebs and the dramaturg and theorist Maximilian Hass. First performed in Amsterdam, the roughly hour-long play involved a troupe of human actors and a donkey (sometimes two). As Haas writes in a text introducing

15. This was one of the driving questions for Jacques Derrida in his late work on animals.

16. Frans De Waal, *Mama's Last Hug: Animal Emotions and What They Tell Us about Ourselves* (New York: W. W. Norton, 2019), 58–59.

the project, rather than mere prop, the donkey was understood as a nontrained actor and protagonist who commanded the play to undercut "cultural conceptions of the animal."[17] On a sparse stage, the human performers in plain street clothes would walk in tandem with the donkey, sit on the side of the stage, lie on the ground, run around, slide, crawl (the only movement that seemed to make the donkey clearly uneasy), eat carrots, roll out a prop cutout donkey, yell "Balthazar" before petting him, and retell the family tree of the animal, who is in fact a female named Lily. For her part, the donkey would smell the floor, sometimes follow, sometimes lead, sometimes ignore, and sometimes walk side by side with these humans. This walking alongside is meaningful, as it denotes comfort and being at ease.[18] Often, when breaking the fourth wall, the donkey would elicit laughter in the audience, even though, of course, the only creature with a theatrical sense of the fourth wall are us humans (as far as we know). While we cannot know if the donkey shares their amusement, her nonplussed reaction seems to relay neither fear nor anxiety.

In this way, *Balthazar* can be understood as theater crossed with behavioral ecology, since it is the nonhuman animal's reactions and interactions with her surroundings that take center stage. By taking the donkey's preferences seriously as both form and content, Weber-Krebs's piece necessarily questions the performance container and its audience's presumptions and demands. While they often played along with the actors, the delegated donkeys just as often became recalcitrant by standing in front of the door they came in through, seeming to express their desire to exit the stage. In Berlin, Weber-Krebs describes a situation where any hope of performing became impossible; the architectural space and a thun-

17. Maximilian Haas, "Balthazar," *Antennae,* no. 31 (2015): 63.
18. See Michela Minero, Emanuela Dalla Costa, Francesca Dai, Leigh Anne Margaret Murray, Elisabetta Canali, and Francoise Wemelsfelder, "Use of Qualitative Behaviour Assessment as an Indicator of Welfare in Donkeys," *Applied Animal Behaviour Science* 174 (2016): 147–53.

derstorm outside found the donkey too ill at ease.[19] This all gives rise to a crucial question: is the nonhuman animal an inadequate actor in such a cultural space, or is it the cultural space itself that is impoverished in relation to nonhuman creaturely demands and desires? The ethological success of this work lies in allowing for the latter to dictate the performances, which let the donkeys become the teachers and trainers. Quite simply, contrary to the relentless demands for spectacle and novelty, a donkey mind and body need care and social settings conducive to their mode of thriving.[20] From this perspective, the theatrical breakdown of the donkeys wanting to exit the stage is the piece's most successful moment.

In referencing Robert Bresson's *Au Hazard Balthazar* (1966), Weber-Krebs and Haas's theater piece invites a retroactive consideration of nonhuman animals appearing in the film, but also any prior visual culture employing animals. Instead of reading the film's nonhuman actor as limited to symbolic foil (often Christological), one could revisit the work by deploying an ethological aesthetics calling on what we now know about animals. Weber-Krebs chose this reference exactly for this reason, as he interprets Bresson's film to be a nonfabular tale.[21] With respect to the examples of Dorgelès, Picabia, Cattelan, Abramovic, and (perhaps) Bresson, none knew exactly what they had, to the extent of their contemporaneous knowledge concerning nonhuman animals, and each remains premodern in that regard. Yet the corrective I propose in the following study is not simply to scour the latest ethological studies for hermeneutical tools and corresponding ethograms. While necessary, this is not sufficient. An art history critically informed by ethology must go beyond scientific constraints to progress and offer something new through its own, though often very different,

19. Interview with David Weber-Krebs, September 24, 2019.
20. In this regard, see the wonderfully counterspectacle documentary film about a donkey sanctuary, *Do Donkeys Act?* (2018), directed by Ashley Sabin and David Redmon.
21. Interview with David Weber-Krebs, September 24, 2019.

constraints. A critical ethological aesthetics will remain vigilant of ethology's "operational exclusions," what Isabelle Stengers, in speaking more broadly about the natural sciences, describes as the self-grounding demarcations of "modern practices" that disqualify "their other—charlatan, populist, ideologue, astrologer, magician, hypnotist, charismatic teacher"—in sum, the sophistry outside the gates of true modern scientific knowledge.[22] The artist is such a sophist with respect to ethology.

This is the reason, Stengers goes on to argue, that the "factishe" is so troubling for modern disciplines. The factishe, a concept borrowed from Bruno Latour, is a mode of existence both found and produced; it is an objective fact of the real whose conditions of possibility and appearance are paradoxically made possible by human techniques of scientific apparatuses. The *fact* in factishe is therefore partly contaminated by nonobjective forms of *fetishistic* sophistry.[23] I will not wade too far into these science controversies, but I do want to suggest that the animal has a similar operational structure. Animals are out there in the real, which has made them available as powerful sites of totemic and fetishistic projection across human myths, folk knowledge, and the natural sciences, the latter often uncritically retaining certain premodern received wisdoms of animals. Therefore, the concept of animality, like a factishe, is both *found* in the evolutionary real of creaturely existence yet also *produced* by the cultures, technologies, and sciences that set the rules for what counts as a living, communicating, feeling, and conscious entity.

Animality would then represent a rather singular factishe, in that the apparatus that both unearths and fabricates the animal is none other than one of its members: *Homo sapiens*. We are the creatures who find and order other creatures, even if historically the self-conscious disclosure of our own creatureliness among other creatures is very recent. From a transcendentally humanist

22. Isabelle Stengers, *Cosmopolitics 1* (Minneapolis: University of Minnesota Press, 2018), 30.
23. Stengers, 31.

understanding of the human—as purportedly standing objectively outside animality—this implicating structure remains invisible or disavowed. The circle remains hidden. From a nonmetaphysical, creaturely understanding of the human—which is the only lucid post-Darwinian point of departure—human knowledge can no longer be seen as standing objectively outside animality. This is even the case for those human qualities deemed anthroproprietary, as uniqueness within a field does not metaphysically extricate one from that field. We might simply be the only creatures that do history in the ways we do, or use technologies to the extent we do, or use symbols in the sophisticated ways we do (should all these qualities actually be discretely human propensities and not permutations of nonhuman animal memory, tool use, and language, which likely involve existential modalities of immeasurable differences that go beyond a sliding anthropocentric scale of life founded in concepts like "sophistication"). Consequently, we *find* ourselves as always already immanent to the creaturely continuum, all while embodying the very measuring devices with which we *produce* our knowledges of nonhuman animals—and of ourselves. In short, the human creature is the factishe of animality from which all other animals are both objectively discovered and subjectively interpreted. This is Giorgio Agamben's understanding of animality—that it originates primarily from within "man" and that the purported human–animal divide has been a decisive force in human history via the "anthropological machine."[24] But what is this creature from which the animal has been produced by human knowledge and history? How do we have access to this creaturely absolute that suffuses the planetary living before it gets chopped up by anthropogenic machines? And what is this creaturely mode of existence for all those nonhuman animals who do not share our epistemological concerns and taxonomies, but quite clearly come up against a meaningful world

24. See Giorgio Agamben, *The Open: Man and Animal*, trans. Kevin Attell (Stanford, Calif.: Stanford University Press, 2004).

and who see, feel, hear, and unearth other entities around them? Thinking along these theriomorphic lines, which turns the tables on the anthropological machine to face the creaturely absolute, makes for an uncanny conception of animals (us included).

This would seem like a proper task for ethology, yet these sorts of speculations are exactly what modern scientific paradigms are (self)constrained against venturing into. The creaturely absolute, that is, the animal unconditioned by the factishe of animality, and indeed any feature of animality that cannot be directly tested and observed in an objective way, is categorically off-limits. Science has the tendency to mistake its cast net for the mirror image of the real, while disavowing anything that eludes its trawling. Vinciane Despret, one of the most compelling philosophers of ethology, notes how the recent scientific literature has rehabilitated animals as more than mere dumb brutes or soulless machines, and yet she is quick to suggest that these modern practices nevertheless betray "less explicit forms of denigration that present themselves under the often noble motives of skepticism, obeying the rules of scientific rigor, parsimony, objectivity, and so on."[25] This scientific skepticism, while sometimes judicious in its cautiousness, can also simply reinforce the operational exclusions that frame modern scientific disciplines. Since animals always seem to find ways of eluding complete disciplinary capture in their complexity, plasticity, and intractable modes of living, when it comes to ethology, the operational exclusion is often the animals themselves, barring a more capacious understanding of the creaturely. This all holds implications for artists who venture into the ethological domain, for again, from a scientific perspective, they will be deemed incorrigible sophists; nonetheless, it is this sophistry that may provide a constructive outsider position free from ethological constraints, from which to speculate on creaturely modes of existence that evade scientific capture. This is why

25. Vinciane Despret, *What Would Animals Say If We Asked the Right Questions?*, trans. Brett Buchanana (Minneapolis: University of Minnesota Press, 2016), 7.

simply integrating a modern scientific discipline like ethology into art history, making the latter fall into the former's scientism, risks methodological naïveness. Instead, artists and art historians have to be critical about ethology's reductive assumptions and operational constrains. Conversely, one of the major questions I work through herein is to what degree more recent forms of cognitive ethology are themselves no longer modern in certain ways and might even be labeled posthumanist in their admittance of, invoking Deleuze, zones of indiscernibility between human and nonhuman—zones which, in truth, have contaminated the comparative methods of ethology from the very beginning. Instead of avowing these zones of indiscernibility between human and nonhuman animals, modern and even some contemporary ethologists will buffer its subjects with skepticism and set the constraints for validating verifiable conclusions, all while limiting any ability to make assertions that exceed experimental apparatus and reach.

Returning for a moment to the precritical understanding of animals in art, it is necessary to call attention to a dialectical twist resulting from these observations: if it is true that "we have never been modern" in Latour's admittedly overused phrase—that is, that we have always been unable to quarantine the nature–culture hybrids—we nevertheless would have had to have *appeared* modern at some point. To *no longer be what one never was* is a strange logic that nonetheless contains a key historical insight, one befitting the wishful discreteness of the autonomous human in humanism. Yet, as I demonstrate in my brief history of donkeys in twentieth-century Western art, when it comes to animality, in so much modern and contemporary art, this historical delusion was never comprehensively reached at all—in large part by having let slip by an uncritical acceptance of timeless and natural conceptions of animality. In other words, when dealing with the creaturely in art, most of our aesthetic practices and discourses have *not yet become modern* in order to then *never have been modern*. An ethologically informed art history will therefore have to work across two phases: first, a backward-looking modern phase that gets art up to speed with etho-

logical knowledge and, second, a forward-looking critical phase that questions the constraints of this same modern scientific knowledge. My hope is that bringing contemporary art and theory in contact with ethological knowledge will result in a critical ethological aesthetics benefiting both sides (if not making them always happy, since the artistically minded will likely begrudge whatever limits are imposed on creativity, while the scientifically minded will likely resent compelling artistic speculations that exceed the paradigms and constraints of experimental observation and truth-claims). In short, ethological knowledge will correct modern and contemporary art practices that remain largely premodern and ignorant with respect to animality, while philosophically informed art theory and practice will confront contemporary ethology with its scientism, which tends toward occlusive skepticism that finds merit only in tractable phenomena without ever questioning that a key existential feature of minded creatureliness might be to elude full tractability.

I run several risks in this endeavor. The history of ethology is complicated, as I summarize in the following chapter, and it is never politically neutral. From the beginning, ethology was interested not only in nonhuman but also in human behavior to varying degrees of nefariousness. Konrad Lorenz, Robert Yerkes, B. F. Skinner, Desmond Morris, and lesser-known scientists working in the fields of animal behavior can be linked to some nefarious political affiliations—Nazism, eugenics, and social engineering. Working with this material can feel like stepping into an analogical minefield, which deserves a whole other study. While properly engaging these analogical dangers exceeds the bounds of this book, I express a commitment to rearticulating animality so that its overbearing pejorative associations are exploded, which might help in undercutting reactionary and racist analogies that lurk uncomfortably in Western historical knowledge, playing certain humans against certain nonhuman animals. From the outset, I also maintain that there have always been two, mutually reinforcing forms of worldly debasement through animalization: that of the human *and* the nonhuman. If a critical ethological aesthetics reveals newly complex

and variegated creatures living behind tired beastly tropes, which heretofore have provided nothing more than projected differential placeholders for humanist superiority, then it will also find creatures that exceed the "animal" in "animalization." This means that nonhumans, too, can be unfairly debased through animalization. This unmooring of the "animal" in "animalization" will allow nonhuman creatures to become newly important across history, culture, politics, and environmentalism as denizens of various stripes. This opens toward a posthumanist or zoopolitical reorientation of formerly anthropo-restricted concerns, which is already well under way and implicates a multidisciplinary platform. As I argue at the end of this book, ecopolitical solidarity is crucial, since the mere fact of knowing more about nonhuman animals through ethological knowledge is likely not enough to notarize cease and desist orders against their relentless debasement and exploitation, though it is an important first step.

Like any other study, this one is limited by my expertise—Western European and certain global practitioners who have invoked animals in their work. I cannot possibly articulate a truly global conception of animality in what is broadly called non-Western cultural production. This would demand an intriguing and welcome volume of many diverse voices and approaches. There is therefore a risk, even when decoding and deconditioning tired Western conceptions of animality, of nonetheless remaining within an all-too-Western discourse. My sneaking suspicion, which exceeds the ambitions of this present book, is that the creaturely absolute might hold a key to a much sought after universality—an extracultural universality that necessarily resides beneath and beyond any universal category as such (and in fact is likely not a category at all but a nonnegotiable and foundational mode of life in the evolutionary real, which is also indelibly connected to the plant world). If one of the major philosophical revolutions of the twentieth century was the grammatological questioning of the primacy of speech, which found talking to be a subset of writing and trace structures, then the twenty-first century may very well give way to a similar dynamic that has long

been in the works: to take seriously our self-knowledge that humanity is a subset of the creaturely and its sentient trace structure. Here it is clear that any politics of rigidity not allowing for flexibility and plasticity is a grave danger. To think culture and politics in a creaturely mode is to affirm foundational capacities and limits based in specific forms of animality, especially the specificity of the human animal, which does not fall into the trap of normalizing immovable or essential categories (as race and gender have been in the history of essentializing human politics). The creaturely has to be understood for what it is: a capacious term for forms of life that find themselves in various and continual states of becoming and "supernormality," to use a useful term from the ethologist Niko Tinbergen, which Brian Massumi has picked up in his philosophical work on what animals can teach us about politics. We are creatures of great plasticity among nonhuman creatures who are also plastic in relation to their capabilities, communities, and worlds.

I define "artist as ethologist" broadly as any practitioner who elucidates nonhuman animal being through a work. This book unfolds along a few paths. First, in the following chapter, I discuss the history of ethology and its possible parallels with art history. This section develops chronologically—from modern ethology and its affinities with modernist art to more recent developments in cognitive ethology and its influence on contemporary art practices. The following chapters then provide ways of rearticulating animals in art, culture, and politics along three steps: (1) deconditioning animality, (2) attempting to enter into speculative nonhuman worlds, and (3) building a multidisciplinary coalition toward a creaturely politics. Although I offer a number of readings along the way of disparate art practices, by no means have artists or the art world as a whole properly internalized the almost daily insights coming from cognitive ethology.[26] The meta-ambition of this book is to galvanize this internalization.

26. A few years ago, when I pitched my now completed dissertation on a hybrid topic in contemporary art and human–animal studies, there was clear opposition to "the animal" as being a proper theme in art history.

Ethology and Art: Modernist Behaviorists and Avant-Garde Field Aesthetics

WHAT IS ETHOLOGY, its history, and its present conditions? This is a complex question involving a hazy division of labor. If ethology is broadly defined as attention to animal behavior, one could go back to Aristotle and Theophrastus, with their cataloging of animal and plant life on the island of Lesbos and its lagoon, or Leonardo da Vinci, with his attentive fondness for animals and patient observations of bird flight. Of course, the modern foundations of the study of animal behavior begin with Charles Darwin, especially in *Descent of Man* (1871) and *The Expression of the Emotions in Man and Animals* (1872). All subsequent ethological endeavors take their cue from the basic Darwinian evolutionary insight that there is biological continuity in nature from which we can undertake comparative study of human and nonhuman animals. The field of modern ethology—or, confusingly, since the cognitive turn, "classical" ethology—officially takes shape along the late nineteenth century up through the twentieth century (since I make epistemic analogies between modern art and ethology, I retain "modern" instead of "classical").[1] Biology

1. *Ethology* was coined in 1902 by William Morton Wheeler, a student of Charles Otis Whitman whose work with pigeons proved to be foundational for animal behavior studies in the United States. Richard W.

is the umbrella discipline under which zoologists, comparative psychologists, and amateur scientists in the field all contributed to the early formation of ethology in a transatlantic network.

Richard W. Burkhardt Jr. has written the definitive Western history of this "ragbag" discipline in his *Patterns of Behavior* (2005).[2] He traces the conditions for the emergence of Lorenz and Tinbergen, often described as the "fathers" of modern ethology, whose work from the 1930s onward paved the way for the theoretical and experimental underpinnings of the discipline, such as the concept of imprinting, instincts and drives, fixed action patterns, and innate releasers. The point of departure for Lorenz and Tinbergen is that animal behaviors can be studied phylogenetically in the same way physiological adaptations and homologies are studied, so that instincts and organs develop in the same way. From the very beginning, ethologists privileged the study of living animals in the field in opposition to traditional zoological taxonomy, which based its knowledge formation on dead specimens in natural history collections, accrued largely through colonial explorations. Ethology also bucked the trend of behavioral psychology, which studied (and continues to study) living specimens confined to purportedly controlled laboratory settings that betray a Cartesian view of animals as mere responsive machines. As Burkhardt shows, while the history of laboratory behavioral work had much stronger institutional alliances and support, a number of key figures developed a field practice of animal observation, including Charles Otis Whitman,

Burkhardt Jr., *Patterns of Behavior: Konrad Lorenz, Niko Tinbergen, and the Founding of Ethology* (Chicago: University of Chicago Press, 2005), 3.

2. Burkhardt. Niko Tinbergen, who, along with Konrad Lorenz, shaped the disciplinary parameters of modern ethology in the twentieth century, is the one who described his discipline as a "ragbag." Burkhardt, 5. For a more general introduction to the history of ethology, see Margo DeMello, *Animals and Society: An Introduction to Human–Animal Studies* (New York: Columbia University Press, 2012), 349–76. See also Colin Allen and Marc Bekoff, *Species of Mind: The Philosophy and Biology of Cognitive Ethology* (Cambridge, Mass.: MIT Press, 2000), 21–37.

Wallace Craig, Jakob von Uexküll, Edmund Selous, Henry Eliot Howard, and other field ornithologists. To a fascinating degree, early ethology was formed by amateurs and outsiders.

Yet the picture is not so simple as closed behavioral control on one side and open field study on the other. After all, ethological scientists working with animals today might employ both forms of study on a sliding scale of control—for example, Frans de Waal's studies on capuchin monkeys are in the lab, whereas Sue Savage-Rumbaugh's work with Kanzi and other bonobos took place in more of a hybrid indoor–outdoor scenario. Even the advent of modern ethology is internally riven. Lorenz's approach has been likened to farming in his study of hand-reared animals on his property as a domesticated topology of observation, whereas Tinbergen's method is likened to hunting in its search for observations in the "wild." Donna Haraway is right in saying that "the privileged place to conduct an ethological analysis" is in the field, while the laboratory has been its "scene of its refinement."[3] Zoos and aviaries should also be added to this disciplinary refinement.[4] That said, it is nevertheless useful to make a broad distinction between two paradigms of animal behavior studies: those employing highly controlled conditions, like today's neobehaviorists, and those situated within an ecological system, like today's behavioral ecologists, whose subjects carry on with various levels of self-direction, be it in the "wild" or in a more confined sanctuary setting.

Intriguingly, this distinction between laboratory control and open field work can be grafted onto certain histories of Western art practice unfolding roughly at the same time, spanning from the 1940s to the 1970s. It can be argued that the reductionist behavioral paradigm betrays an impulse for abstraction as a form of zeroing in and distilling, akin to Robert Motherwell's definition of abstraction. Analogical examples from the history of animal be-

3. Donna Jeanne Haraway, *Primate Visions: Gender, Race, and Nature in the World of Modern Science* (London: Routledge, 2015), 140.
4. Burkhardt, *Patterns of Behavior*, 7.

havior studies include locating a fixed inherent instinct—a la the Lorenzian ideal—or isolating an animal to reach the zero degree of its capacities, as in the operant conditioning chambers of the behavioral psychologist B. F. Skinner and the notorious depravation experiments by another psychologist, Harry Harlow. Working out of the University of Wisconsin in the 1950s, Harlow developed an indoor breeding program of macaques on an unprecedented scale to produce immunologically clean monkey bodies for undergoing tests (which, note, already entails an abstracted body in some sense). These included affectional tests with "surrogate mothers" and sensory deprivation tests in contraptions like the "well of despair."[5] The basic procedural paradigm was to isolate subjects to reduce their developmental capacities in relation to fixed stimuli so as to mold the subject into desired form. Echoing ambitions of social engineering, Harlow described the difficulties of this procedure: "The challenging problem is to produce laboratory environments in which the feral animal transcends its feral capabilities. What man did for man he should be able to do for monkeys."[6] It is difficult to imagine a more fitting laboratory example of the animal factishe. It is also unsurprising that Harlow's work augured "learned helplessness techniques"—shock treatments induced in monkeys and dogs across various laboratories decades hence—which would become well-remunerated fodder for a couple of psychologists contracted by the Central Intelligence Agency (CIA) to develop "enhanced interrogation techniques" for the purposes of breaking down terrorist suspects during this century's so-called war on terror.[7]

5. See Haraway, *Primate Visions*, 231–43.

6. Haraway, 236.

7. These "learned helplessness techniques" were also first developed at the University of Wisconsin in 1977. They are most synonymous today with the American psychologist Martin Seligman, who, much to his chagrin, inspired two psychologists contracted by the Central Intelligence Agency (CIA) to use these techniques on humans for its torture program. See the film *The Report* (2019), directed by Scott Z. Burns, for a compelling fictionalized account.

It is remarkable, then, to think that during the 1940s and 1950s, the New York School of abstract expressionist painters was interpreted as isolating and abstracting visual experience in similar ways. In both behavioral psychology and formalist art criticism, there is a desire for an autonomous entity plucked from its sociocultural conditions—one living and animate, the other painted and inanimate. Both betray forms of sublimation—one of animality into something controllable, the other of emotions into something beautiful. The foremost formalist critic Clement Greenberg's repeated allusion to Kant, namely, that modernist painting revealed the "conditions of possibility" inherent to its medium, can be applied to Harlow and his misadventures in finding (though ultimately factishiously *producing*) the conditions of possibility for maternal affection or depression. In both cases, the act of distilling amounted to a filtering of external noise, with the laboratory and studio as compatible sites of control seeking to bracket off the outside (the same could be said about contemporaneous first-order systems theory and New Criticism). Yet, as so many postformalist art historians have since noted, contrary to Michael Fried's devaluation of "theatricality" in "Art and Objecthood," his canonical essay defending formalism, the search for autonomous visual experience amounts to a disavowal of the ambient unfolding of objects and subjects within their social, political, and ecological contexts. This is the price paid for autonomy and isolation, be it on a canvas or in a lab. In both cases, the reductive results were recoded at will. In Harlow's hands, for example, monkeys would reinforce the U.S. heterosexual family unit, as Haraway argues in her classic *Primate Visions*, whereas in the Museum of Modern Arts' (MoMA's) hands (not without some help from the CIA), abstract painting would reinforce U.S.-style individualism and freedom.[8]

The other paradigm of studying animal behavior, namely, field ethology or behavioral ecology, finds its aesthetic correlate in the

8. Haraway, *Primate Visions*.

disparate neo-avant-garde impulses for collapsing life into art, which would thumb their noses at modernist autonomy. Staying for the moment in a U.S. context, Robert Rauschenberg's and John Cage's work represented a clear challenge to art modernism in its embrace of ecological variants and chance effects. Rauschenberg's early paintings are prime examples, especially the white paintings of 1951, with their material openness and generosity to their surroundings—from settling aleatory dust to viewers' fleeting shadows.[9] It is unsurprising that Rauschenberg's subsequent combines would attract and incorporate wildlife, famously a stuffed goat and bald eagle (however nonethologically), or that his dance performance *Elgin Tie* (1964) involved a living cow. As for Cage, his "silent" avant-garde piano piece *4'33"* (1952), which was inspired by Rauschenberg's white paintings, might be described as an ethological experiment of human behavior within an aesthetic moment of sonic deprivation that gets unavoidably disturbed by its restless participants. Both Rauschenberg and Cage challenged modernist autonomy and the drive for isolation and abstraction in their generosity to material plasticity and ambient conditions. Living movements and behaviors in their reach were aesthetically interpolated, often in a Zen-like openness to even the most minor of variations, unknowingly echoing the early ethologist and ornithologist Charles Otis Whitman's "modes of keeping quiet."[10]

The breakdown of modernist autonomy is rather like the modern ethological sciences ultimately finding it impossible to absolutely localize animal behaviors under study. The moment a researcher shifts her paradigm away from isolating animal subjects or traits toward an embedded paradigm of variable social and ecological contexts is the moment any hope of abstracting an autonomous subject evaporates. This is the becoming avant-garde of ethology, which, in many ways, field ethology had always been without fully

9. See Branden W. Joseph, *Random Order: Robert Rauschenberg and the Neo-Avant-Garde* (Cambridge, Mass.: MIT Press, 2007), 25–72.

10. Burkhardt, *Patterns of Behavior*, 22–23.

knowing it, as was the case with Tinbergen in his research on various seagull species beginning in the 1950s. With the observational help of his students in the field (many of whom were women, a notable detail deserving of further study), he had to admit that animals hold certain character developments in their ecological niches that go beyond simple automated instincts. Attesting to cognitively sophisticated behavior, kittiwakes' idiosyncratic removal of eggshells from their sea cliff nests were interpreted to be site-specific antipredatorial maneuvers. Herring gull chicks, for their part, were observed pecking to receive food through a variable set of triggers in their demand for food—and not simply the "natural" red dot on their mothers' bills. A number of alternatively tested stimuli did the trick—at times even more effectively.[11] A surprised Tinbergen described this as "supernormal stimuli," and in his Deleuzian extrapolation of this supernormality, Massumi convincingly argues that even within the rules of Darwinian evolution, instinct has to outstrip itself. Were this not the case, adaptability to ecological realities would become fixed, which would eventually put an end to said adaptability. Tinbergen's and Massumi's creatures turn out to be a serious challenge to any established scientific demands for tidy classification and generalizability in their propensity for creativity, improvisation, and variability.

Most striking is when nonhuman animals are observed to be very unmodern in their behaviors and capacities that no longer place them safely on the other side of culture, communication, and politics. The moment a researcher sees herself in the animals she observes and feels the creaturely continuum that exists between them is even more revealing. When this happens, ethology becomes radically avant-garde, if not downright ecofeminist and new materialist. If modernism, in both art and science, presumed the view-

11. Brian Massumi, *What Animals Teach Us about Politics* (Durham, N.C.: Duke University Press, 2014), 15–17. For a more developed analysis of this episode, see his "The Supernormal Animal" in *The Nonhuman Turn,* ed. Richard Grusin, 1–17 (Minneapolis: University of Minnesota Press, 2015).

er (or scientist) to be transcendent and outside the artwork's (or the experiment's) autonomy, then the collapse of this paradigm opens a necessary path toward the posthumanities, which allows for manifold human–nonhuman entanglements.[12] The merit of the posthumanities is that they excel in insisting on the fictiveness of the humanist subject—which, nonetheless, has had very real historical effects, not least of which has been supplying the ground for both modern art and science alike. The precept of a posthumanist world finds the artist, the scientist, and the viewer inextricably immanent to and conditioning the artwork or experiment in various ways. Most impactful here is the avowal of other minds beyond the human. Lorenz and Tinbergen were invested in lending credibility to ethology in the eyes of the hard sciences, which led them to deny nonhuman inner cognitive life in its purported unobservability. Instead, they sought to establish a discipline with no preconceived notions outside tractable objective facts. Tinbergen explicitly turned away from dealing with nonhuman mindedness: "I realized that the further analysis of the physiology of behavior would have to dig into the nervous system. Here I balked; I was not really interested in poking inside a system that seemed much too complex to me."[13] The philosopher Laurent Dubreuil's description of a discipline prefiguring "the knowable at the very moment it raises its first questions" could not be more apt.[14] The nonhuman animal mind is occluded by the very discipline begging to proffer some insights.

The decisive paradigm shift in ethology arrived with the pioneering work of Jane Goodall in the 1960s and her *In the Shadow of Man* (1971) and with the work of Donald Griffin in the 1970s, who is

12. With "posthumanities," I allude both to Cary Wolfe's influential series at the University of Minnesota Press and to any interdisciplinary space that challenges dogmatic concepts of the human in humanist history.

13. Tinbergen to R. W. Burkhardt, May 20, 1979. Cited in Burkhardt, *Patterns of Behavior*, 410.

14. Laurent Dubreuil, *The Intellective Space: Thinking beyond Cognition* (Minneapolis: University of Minnesota Press, 2015), 19.

often considered to be the founder of "cognitive ethology," having written *The Question of Animal Awareness: Evolutionary Continuity of Mental Experience* (1976). Both scientists opened the field to allow for mindedness, emotions, and social complexity. This is not a historical straight line, however, as one could invoke the British amateur ornithologist Henry Eliot Howard, who maintained that nonhumans have an aesthetic sense, or Darwin and his followers, like George Romanes, who, as "anecdotal cognitivists," made many more allowances for the complexity of animal life. And yet, for all its advances, cognitive ethology can also be isolationist and abstractionist when mindedness is reduced to the brain and nervous system—in a word, to the "cognitive." For example, the analytic philosopher Colin Allen and cognitive ethologist Mark Bekoff offer a compelling naturalist defense (i.e., that mindedness is fully part of the physical world) of cognitive ethology in what they argue to be a more objectively tractable version of Griffin's cognitive ethology. In doing so, they take recourse to neuroethology, which hopes to account for the evolution of nervous systems in relation to their behavioral functions.[15] Complications arise, however, when we note the extracognitive realities that condition the mindedness of both humans and nonhumans. The enteric system alone—with its microbiomic affects and digestive noise along the gut–brain axis—sends any isolationist claims of mindedness as reducible to the cognitive into crisis. For these reasons, we need a way of researching and coming to terms with other minds in ways that are more capacious than the cognitive alone. This is one of the major contributions of Dubreuil's work on "the intellective space."[16] His conception of the intellective—which calls on literature, analytic philosophy, Continental philosophy, and the cognitive sciences—represents an indispensable starting point for my present study.

The posthumanist avant-gardism of ethology I am describing here has played a serious, if still controversial or not fully avowed,

15. Allen and Bekoff, *Species of Mind*, 13.
16. See Dubreuil, *Intellective Space*.

role in the recent history of cognitive ethology, primatology, and behavioral ecology. Some scientists and researchers still cling to the modernist paradigm and its inadmissibility of sophistry in favor of a strict positivism of tractable phenomena. Others are more generous and open to a richer conception of nonhuman alterities. Mirroring the old debates of art modernism I gloss in the preceding pages, it is telling that this latter group often grasp a bigger picture of the social, political, and ecological stakes involved. Like Allen and Bekoff, this group is likely also adamant that the study of animal behavior necessitates an interdisciplinary approach: "It is our view that the best way to understand mental-state attributions across species boundaries is within the comparative, evolutionary, and interdisciplinary framework provided by cognitive ethology."[17] Not only does this amount to admitting that ethology cannot be a discrete and autonomous modern science but it also points to my central argument that cognitive ethology is necessarily posthumanist, even if it does not know it yet. This is so in the two interrelated ways I have just outlined: as a disciplinary field, it cannot possibly be isolationist or abstractionist, which is why even the term *cognitive* needs to be expanded, and its human researchers are fundamentally immanent kin in relation to the nonhuman creatures they hope to understand.

Recognizing that the study of animals necessitates an extrascientific companion discipline can be found at the advent modern ethology—and from an unlikely source: C. Lloyd Morgan. His eponymous "canon" is often cited as the joy-killing law decreeing to researchers that they should never appeal to higher mental states when lower ones can do the job. Yet, in a 1912 correspondence with Henry Eliot Howard, in which they consider the phraselike structures of bird song, Morgan appeals to aesthetic experience:

> I often think that a sort of unanalyzed sympathetic artistic sense set a man nearer to the secret of the animal mind than scientific thought

17. Allen and Bekoff, *Species of Mind,* x.

which is at home in the midst of a more intellectual mode of psychological development. But it's very hard to express oneself comprehensibly in this matter.[18]

Much later, Jacques Derrida will say something similar in claiming that "thinking concerning the animal, if there is such a thing, derives from poetry."[19] Both Morgan and Derrida—one with respect to science, the other to philosophy—question the limits of their disciplines and appeal to an artistic supplement. In both instances, this supplement is mysterious and only uneasily integrated within the comparatively more "rational" discipline. With this we arrive at the broadest issue driving this book: what happens to ethology and the study of animal behavior when the contours of its creaturely subject-object of study can only be traced, alluded to, formulated, touched, and communicated by an artistic jump or, perhaps, even leap of faith? If this is the case—that is, that certain ontological and epistemological truths can only be ciphered through judicious aesthetic fictions—then is this not what art practices can bring to ethology? The opposite question will also have to be posed, namely, what can ethology bring to art? And what if ethology already holds more affinities with art history than originally thought? Perhaps interpreting the living interiority of an animal is akin to unpacking the historical interiority of an artwork: both entail negative epistemologies of knowledge gleaned from opaque contexts that nonetheless point to a truth we cannot experience directly—one in a living body before us, the other in a historical past behind us.

In fact, there is a considerable and untapped history of artists thinking and practicing like ethologists, as well as scientists working with aesthetic knowledge, beginning with Darwin and his sugges-

18. Morgan to Howard, May 29, 1912. Cited in Burkhardt, *Patterns of Behavior*, 95. It turns out that birds do phrase; see Eva Meijer, *When Animals Speak: Toward an Interspecies Democracy* (New York: New York University Press, 2019), 54–55.

19. Jacques Derrida, *The Animal That Therefore I Am,* trans. Marie-Louise Mallet (New York: Fordham University Press, 2008), 7.

tive advice to analyze painting and sculpture as part of his six methods for studying emotional expressions.[20] Answering these sizable questions would entail a team of art historians, science studies, and critical animal studies scholars. A particularly useful starting point and compendium for this endeavor would be the exhibition *Animal Art 87* in Graz, Austria, which comes with an invaluable cataloging of disparate artistic practices invoking the creaturely, roughly from the 1960s to its present day (a similarly ambitious exhibition from the subsequent three decades, which ideally would be more global in scope, is much needed). Nearly every position vis-à-vis the animal I have demarcated so far is represented: performance artists trafficking in atavistic ritualism with animals; installation artists whose projects double as behavioral psychology experiments; artists working in the field like modern ethologists; and, most compelling, artists who fit the mold of posthumanist ethologist whereby any subject–object distinction is thrown out the window.[21]

One thing is for sure: artists are simply freer than scientists. Making creaturely claims through an aesthetic practice has less (or different) institutional and epistemological constraints than making scientific claims. In this way, artists can be more daring in their expositions of animality and less daunted by aporia when face-to-face with nonhuman life. Aesthetic practices also have a different relation to the truth and the real, both being had or known through more metaphoric, oblique, asymbolic, and affective procedures. Yet, it should be said, art is as pharmakological as science—both poison and cure, help and hindrance—and in such a way that makes their relationship chiasmatic: if science is more rigorous, thereby paying the price by wielding a restrictive set of rules for making truth-claims, then art's comparatively freer protocols can, for its turn,

20. Allen and Bekoff, *Species of Mind*, 25.

21. For a by no means exhaustive treatment of this important exhibition, see my "Animal Art 87 and the Split Origins of Bioart" in *The Routledge Companion to Biology in Art and Architecture*, ed. Charissa N. Terranova and Meredith Tromble, 317–35 (New York: Routledge, 2016).

lead down a slippery slope of lacking rigor altogether or of using scientific knowledge in shallow or irresponsible ways. Leaving aside the many thoughtless incorporations of animals in art, the risk here is of making naive or exorbitant claims about nonhumans or arriving at a mere aestheticization of science, something for which Élizabeth de Fontenay has severely criticized bioart in what she deems its puerile experiments.[22] If artists employ scientific techniques for noninstrumental ends—be it gene technology or ethology—it will have to press beyond mere novelty. Most crucially, artists will have to say something about science that science categorically cannot say or see about itself.

22. See Élisabeth de Fontenay, "The Pathetic Pranks of Bio-Art," in *Without Offending Humans,* 111–25 (Minneapolis: University of Minnesota Press, 2012).

Step 1: Deconditioning Animality
(Still Humanist in Certain Regards)

IN 1950, the surrealist poet Jacques Prévert and Ylla, then a cele-
brated animal photographer, published *Des bêtes . . .*, a photobook
collecting the photographer's black-and-white images of companion
species, farmed animals, and zoo animals.[1] The images are accom-
panied by an extended free verse poem by Prévert, which begins
with a conscious stripping away of all fabular connotations that
risk clinging to the animals pictured. Instead, Prévert emphasizes
that "these animals," unlike those in fables, actually exist. They
live, die, feel joy and sadness, and much else. As such, *Des bêtes . . .*
is an ethological photo-poetics that begins to decondition tradi-
tional zoo-tropes. The book is an act of *epoché* or a suspension of
prejudices concerning certain species to begin seeing animals in-
themselves. Vinciane Despret has aptly described this procedure
as encountering "animals as if they were strangers, so as to unlearn
all of the idiotic assumptions that have been made about them."[2]
Ylla's photographs lend themselves to this deconditioning of an-
imality by undomesticating their subjects, however modestly, in

1. Jacques Prévert and Ylla, *Des Bêtes . . .* (Paris: Gallimard, 1950). (Ylla
was born Camilla Koffler.) Ylla also published *Animal Language* (1938) and
Animals (1950) with the evolutionary biologist Julian Huxley.
2. Despret is alluding to Donna Haraway in this passage. Despret,
What Would Animals Say?, 161.

their focalizations that strip away signs of zoological confinement and display (aside from the occasionally unavoidable cage bars). Her portraits reveal animals at idiosyncratic moments pointing to an array of inner states: a forlorn orangutan pressing mouth and cheeks through cage bars, two chimpanzees with arms affectionately wrapped around each other's shoulders, a bored lion mid-yawn, aimless penguins, elephants splashing in a pool, and sundry other animals, nearly all close up and nearly all directly addressing the camera. This stylistic lack of context suits Prévert's opening poetic gesture of defamiliarization. True, Ylla's portraits are, at times, problematically humanizing, but they are also often evocative of the expressiveness of other minds. As a result, the viewing reader has to make some ethological decisions with all these empathic encounters of flesh and blood—*what is coming from me, and what is coming from them?*

The 1960s and 1970s were an especially rich moment for zoos influencing artists: the painter Gilles Aillaud, who, unlike Ylla, nearly always contextualized zoological architecture and design in his paintings, ironized the wild painterly *animalier* genre; an early unrealized screenplay by Marcel Broodthaers is set in the Antwerp Zoo, which eventually led to his employment of a living camel from said zoo in his *Un jardin d'hiver* installation in 1974; Francis Bacon's zoomorphic paintings of dark bestial smears in confinement and anguish (which begin in the 1950s) were based on photographs from zoos, as well as on Eadweard Muybridge's *Animals in Motion* (1899), itself featuring animals from the Philadelphia Zoo; Garry Winograd's *The Animals,* a series of black-and-white photographs from his visits to the Central Park Zoo in New York City, was published in 1969; around the same time, Simone Forti's dance practice was influenced by the nonhuman gestures at the Rome zoo, as was Arte Povera artist Pino Pascali's work;[3] the films of Chris Marker—

3. See Julia Bryan-Wilson, "Simone Forti Goes to the Zoo*," *October* 152, no. 1 (2015): 26–52; Giovanni Lista, "Les animaux imaginaires de Pino Pascali," *Ligeia,* no. 1 (2016): 145–48.

himself directly influenced by ethology, having translated one of Lorenz's popular ethology books into French—represent a long-running preoccupation with animality, from the extended scene of animal taxidermy in *La jetée* (1962) to all the zoo animals in *Si j'avais quatre dromadaires* (1966/1974) to his *Bestiaire* videos (1985–90), which include the melancholic *Zoo Piece*. Examples of artistic engagements with zoological institutions abound.

Outside art proper, the 1970s saw John Berger publish several essays on the zoo that were consolidated in his celebrated "Why Look at Animals?"[4] One of Berger's central claims is that zoological displays always disappoint. The animals are neither vital nor visible enough for public expectations. In 1972, the systems anthropologist Gregory Bateson—who we will see undertook ethological study of cephalopods and cetaceans—published *Steps to an Ecology of Mind*. This compilation includes a well-known essay on his theory of animal play in which he recounts a visit to the San Francisco Fleischhacker Zoo, evincing a rather different experience from Berger's.[5] Confronted with two monkeys tussling in their enclosure, it became clear to Bateson that their gestures were not truly combative but in fact ludic. They were play fighting. This may seem prosaic, yet as Brian Massumi elaborates in his political theory of animality, which takes Bateson's observations of creaturely play as its point of departure, it should never be underestimated.[6] The ludic register turns out to be foundational for the affective paths that animal life takes on this planet, human and nonhuman, running along sympathy, intuition, and desire, all the way to creativity, language, and politics. As Bateson readily admits during his zoo visit,

4. Jonathan Burt's critical reading of Berger's essay accounts for the installments composing the final essay: "The first appearance of 'Why look at animals?' was as three separate articles published in *New Society* in March and April 1977." Burt, "John Berger's 'Why Look at Animals?': A Close Reading," *Worldviews* 9, no. 2 (2005): 203–18.

5. *Steps to an Ecology of Mind* is a collection of Bateson's writings. The essay in question, "A Theory of Play and Fantasy," dates back to 1955.

6. Massumi, *What Animals Teach Us*.

this primate combativeness holds denotive and even metaphorical meanings. When wolf cubs engage in play fighting, they enter a mutual field of gestures that necessitate decoding, wherein bites hold polyvalent meanings beyond clear-cut aggression. As Massumi argues, animal play reflects a mode of corporeal signification and transindividual meta-communication that model human language, which has simply taken the metaphoric resonance of corporeal play to "a higher power."[7]

In the broadest sense, what artists visiting zoos understand implicitly, which Bateson and Massumi understand explicitly, is that animality is always in a state of supernormality. Play is a lived pleasure, but it is also a prosocial mode of learning and practice. As such, play complicates any notion of purely instinctual life (as Tinbergen was taught by those kittiwakes and herring gulls). The importance of supernormality cannot be overstated in its defamiliarization of animality, both in premodern folk beliefs and in modern ethology: in direct contrast to the long-held views that nonhuman animals are mere brutes ruled by fixed instincts, to be a creature is to have the lived proclivity for judicious responsiveness and variation. Again, this is for a simple and profound reason: "if the instinctive act were as it is reputed to be—a stereotyped sequence of premodeled actions executed by reflex in the manner of automatism—then instinct would be incapable of responding to chance changes in the environment."[8] Nonhuman existential plasticity unfolds in negotiation with the immunological spaces of the living, from nests to hives, dens, houses, packs, families, kin, and friends. This is one reason why zoos are so evocative of supernormal states: they are sedentary immunological (arguably autoimmunological) confines that are often ill suited to the living desires of their denizens, from which affective states ensue that exceed conventions and tropes—be it entering into profound boredom

7. Massumi, 8.
8. Massumi, 13. Massumi is alluding to the work of the French philosopher Raymond Ruyer from the 1950s.

and malaise, as in Berger's observations and Marker's *Zoo Piece,* or into play and variation, as in Bateson's and Massumi's accounts, or ending in outright revolt or escape.[9]

Contemporary artists have only begun to crack the surface of the deconditioning possibilities of supernormality. Existential plasticity complicates the reduction of the animal to mere medium or installation object and raises the seriousness of nonhuman performance. There are, however, some artists who offer creative forms of deconditioning animality by way of such ethologically inflected practice. The late Martin Roth's work, which incorporated animal and plant life in considered ways, is a great example. An early piece saw him raise a brood of ducklings in his studio, the duration of which ended when the birds were old enough to be released into the wild. A video shows the artist feeding the ducklings and facilitating a group swim in the tub and the birds playing on a floor strewn with brown leaves.[10] Admittedly, this early work does not move beyond a Lorenzian form of rearing and imprinting and is largely an aestheticizing exercise in modern ethology. Roth's *In october 2014 i rescued laboratory mice so they could play swan lake, 2014,* however, goes further. The installation featured two mice who had been bred in a lab and used in biomedical research. The artist rescued his subjects by convincing an anonymous researcher to hand them over rather than "destroying" them, as required by law.[11] Roth placed the mice in a specially made glass terrarium filled with grasses, pebbles, and

9. Jason Hribal, *Fear of the Animal Planet: The Hidden History of Animal Resistance* (Edinburgh: AK, 2011).

10. Martin Roth, *In the fall of 2010 I raised ducklings in my art studio. i later released the ducklings into the wild* (2010). There is a short video of the ducklings online: Martin Roth, "ducklings new movie," YouTube video, 4:07, https://www.youtube.com/watch?v=gTHR6zKlT7E.

11. In conversations I had with the artist about the making of this work, Roth never disclosed where the mice came from, and this remained shrouded in necessary secrecy. The installation was included in an exhibition I curated at Vohn Gallery in New York City titled "autoimmune," which ran from October 22 to November 28, 2014.

dirt, along with a metal wheel connected to a music box mechanism. When the mice played with the wheel, Tchaikovsky's well-known melody from the ballet lending the installation its name sounded throughout the gallery.[12] It became clear to Roth early on that the mice did not come readymade with mousehood.[13] Since they were bred in sanitary laboratory conditions, deprived of the immunological benefits of the great outdoors, a pedagogic collaboration ensued between artist and mice so that the latter could learn to live with novel earthly elements.[14] They had to be taught how to eat pellets and seeds, dig in dirt, and cope with sunlight. This means that the mice were not necessarily fully encoded to be mice, nor can they be considered to be purely conditioned laboratory subjects. Instead, they expressed variable lived proclivities that unfolded in both sterile laboratory conditions and in the nurturing habilitation of Roth's terrarium and its microecology.

The past ten years of research on rodents reveals that they are anything but unsophisticated creatures who simply follow their baser instincts. In altruistic fashion, mice will liberate fellow mice from confinement in clear tubes when they can, while rats will readily help conspecifics in danger of drowning, even if presented

12. For a brief installation video of one of the mice playing with the wheel, see Martin Roth, "swan lake clip," YouTube video, 0:21, https://www.youtube.com/watch?v=6eB_2t2v6rM.

13. That is, should such an essentialist categorical entity as "mice" exist, something the becoming-animal of this work goes to destabilize.

14. The two mice lived for only another half year or so after the installation. One of the realities of laboratory existence is a compromised immune system. Sterile laboratory ecologies do not allow for microbiotic exposures and entanglements we now know are crucial for animal life, further putting a nail in the coffin of behavioral reductionism. Scientists are now debating the controlled introduction of "dirty" mice to facilitate healthier immune systems in their test subjects. See Cassandra Willyard, "Send in the Germs: Lab Mice Are Usually Kept Squeaky Clean, but Some Immunologists Think a Dose of Dirt Could Make Them More Useful for Science," *Nature* 556, no. 7699 (2018): 16–18.

with chocolate as an alternative.[15] These findings are suggestive of flexible prosocial and empathic forms of community making, which refute conceptions of animality that are reducible to behavioral automation or all-encompassing instinctual drive for pleasure and preservation. These experiments, which sometimes involve elaborately designed contraptions of varying degrees of induced duress, can be thought of as participatory art installations thematizing conviviality in miniature. Be it in the laboratory, the wild, or an art installation, mice evince supernormal behaviors within environmental and genetic limits that exist across all forms of animal life. It had long been dogma that only domesticated and confined mice use wheels and that this propensity is symptomatic of a pathological condition. We know today, however, that even mice in the wild willingly run inside wheels.[16] Rather than mindless behaviorism or a pathological result of confinement, running the wheel is, quite simply, a source of nonessential enjoyment. Play and sociability; pure joy and empathy—these purportedly humble rodents go a long way in deconditioning animality.

If mice can be taught to be mice, then their existence is, in part, a form of acculturation. Supernormality always presupposes a capacity to learn. Perhaps the most sought after propensity for nonhuman acculturation is that of entering the symbolic worlds of human meaning—especially speech. This fascination is evident in art installations that hope to inculcate speech in birds, notably those species of parrots and corvids who demonstrate the cognitive and physiological capacity to emit phonetic signs. Think of Hans

15. See N. Sato, Ling Tan, Kazushi Tate, and Maya Okada, "Rats Demonstrate Helping Behavior toward a Soaked Conspecific," *Animal Cognition* 18, no. 5 (2015): 1039–47; Hiroshi Ueno, Shunsuke Suemitsu, Shinji Murakami, Naoya Kitamura, Kenta Wani, Yosuke Matsumoto, Motoi Okamoto, and Takeshi Ishihara, "Helping-Like Behaviour in Mice towards Conspecifics Constrained inside Tubes," *Scientific Reports* 9, no. 1 (2019): 5817.

16. See Johanna H. Meijer and Yuri Robbers, "Wheel Running in the Wild," *Proceedings of the Royal Society, Series B: Biological Sciences* 281, no. 1786 (2014): 1–5.

Haacke's *Norbert: "All System's Go"* (1970–71), Rose Finn-Kelcey's *One for Sorrow, Two for Joy* (1976), or, more recently, Agnieszka Kurant's *Ready Unmade* (2008).[17] Kurant taught three macaw parrots to bark by isolating them with recordings of dogs, which they could only do imperfectly. The delicious irony here is of an animal with the capacity to enunciate human speech being unable to fully replicate the sounds coming from another animal who cannot (though canines do have the capacity for a one-way understanding of certain human sound signs). It was only when the installation—a large metal cage with tree branches and plants—was made public that the macaw parrots were immersed in human sounds, which they had an easier time enunciating, and which we know today they have a modicum of self-reflexive understanding in using. A nonhuman animal speaking—and not simply "parroting"—challenges Western histories of animality grounded in the Aristotelian lineage of man as the only rational animal. In truth, this challenge had already begun in the Enlightenment, when the origins of language became a central concern.[18] Even before its verification, John Locke was convinced by the vocal rationality of a singular parrot.[19]

One of the most compelling works exploring avian communication is Allora and Calzadilla's *The Great Silence* (2016). The three-channel video installation is a collaboration between the artists and the science fiction writer Ted Chiang, whose short story lends the work its name and provides its narrative. The story is an extended rumination on an analogical disconnect between the Fermi paradox and nonhuman animal intelligence, specifically that of parrots. The Fermi paradox states that the universe is so vastly old that intelligent life must surely have arisen many times—and yet, no signs of such life exist. That this would be the case is perplexing, if not truly paradoxical. Chiang's story proposes, however, that signs of nonhuman intelligent life have been here all along: clever nonhuman creatures,

17. Kurant's installation was shown at Frieze Projects in London in 2008.

18. See Tobias Menely, *The Animal Claim: Sensibility and the Creaturely Voice* (Chicago: University of Chicago Press, 2015).

19. Locke met Prince Nassau's parrot. Agamben, *The Open,* 24.

like parrots, can be rediscovered as intraterrestrial aliens (in itself, this is a wonderful deconditioning of animality). Chiang's analogy is visually reinforced by Allora and Calzadilla's juxtaposition of shots from two locations in Puerto Rico: the Rio Abajo State Forest and the nearby (now defunct) Arecibo Observatory. The first is home to the Luquillo Aviary of critically endangered Puerto Rican parrots; the second is a massive radio telescope built in the early 1960s dedicated to finding signs of extraterrestrial life. The fact that Arecibo is ensconced in a landscape only a short distance from the Rio Abajo Forest, which was once home to an abundance of wild Puerto Rican parrots, reinforces the disconnect between the technodesires of alien communication and the invisibility of intelligent nonhumans and their ecosystems. Like Thales falling into a hole when fixating up at the sky, the desire to commune with the stars blinds one to already-existing communicative potential on earth.

The Great Silence's imagery comprises slow panning shots of the massive observatory dish and its surroundings, real-time graphic readouts of cosmic electromagnetic waves, the Rio Abajo Forest, and Puerto Rican parrots whose deep emerald green plumage, blue-tipped wings, and splash of red just above white beaks provide striking color. The textures of the film are as much sonic as visual. There is the rich diegetic sound of the Arecibo humming a continuous and deep sonorous white noise that cuts away to the ambient forest ecology of trees and birds. Noticeably absent, however, are any spoken words. Instead, Chiang's short story appears at the bottom of the screen as subtitles. Since the narrator is a parrot, technically speaking, the story is written in first-nonhuman-person—and throughout the film, this avian narrator makes a compelling case for reconsidering her kind as an ethological counterhistory: "Humans have lived alongside parrots for thousands of years, and only recently have they considered the possibility that we might be intelligent."[20] In speaking of their likely extinction, the narrator attests

20. *Great Silence,* 8:56.

that this would mean not simply the loss of a group of birds but "also the disappearance of our language, our rituals, our traditions."[21] Clearly this parrot is making some cutting-edge ethological claims.

By giving the parrot narrative duties, Chiang is indulging in hyperbole. As far as we know, the complexity of the implied speech in the written text exceeds the cognitive capacity of any parrot to enunciate. Yet this is not anthropomorphism pure and simple. This artistic license is one of degree and not of kind, for parrots *can* speak and *do* understand what they are saying, if not at this level of linguistic sophistication.[22] That we know this is thanks largely to one of the most famous parrots who ever lived: Alex, Irene Pepperberg's celebrated grey parrot subject of some thirty years. If there was ever an animal who deconditioned myths about his kind, it was Alex.[23] In making her ethological counterhistory, the narrator in *The Great Silence* nominates Alex as ambassador and proof of nonhuman communicative potential. In fact, the final lines of the film recall one of the last phrases spoken by Alex the evening before his passing: "You be good. I love you."[24] Alex would say this to Pepperberg nearly every evening, so it was likely not a premonition (as the film seems to imply). This does demonstrate, however, an instance of nonhuman speech attesting to affection—if not "love," should that word even be precisely determinable by the humans who use it, then at least a feeling of bonding, care, or appreciation. With Alex as representative of parrot intelligence

21. *Great Silence,* 14:14.

22. If one is feeling comparative, Parrots can reach the level of speech proficiency of a young human child. See Irene M. Pepperberg, "Cognitive and Communicative Abilities of Grey Parrots," *Current Directions in Psychological Science* 11, no. 3 (2002): 83–87.

23. For a readable and personal account of their collaborative research and Alex's feats of cognition, see Irene M. Pepperberg, *Alex and Me: How a Scientist and a Parrot Discovered a Hidden World of Animal Intelligence—and Formed a Deep Bond in the Process* (New York: Harper, 2009).

24. *Great Silence,* 16:20. Although it is true that these were Alex's last words to Pepperberg, this was part of their nightly parting ritual. Pepperberg, *Alex and Me,* 207.

and emotion, the sounds in the Rio Abajo Forest and the Luquillo Aviary no longer read as aleatory sounds of nonmeaning, like wind or water. Now the nonhuman voices are imbued with rich intention (if inaccessible for human listeners). The narrator references ethological research reporting that parrots have a unique self-identifying "contact call," which is repeated by fellow parrots in what can be described as acts of individuation, naming, and mutual recognition.[25] So it is not just Alex who can use vocal sounds to indicate things in the world; the calls in the forest indicate a soundscape allusive of nonhuman community.

With its emphasis on speech, *The Great Silence* holds a central irony that is also its flaw, albeit a highly constructive flaw. The film proffers parrot intelligence by focusing on the ability for vocal learning. The narrator affirms that, unlike dogs, who understand commands but can only bark in return, humans and parrots "share a special relationship with sound. We don't simply cry out. We pronounce. We enunciate."[26] The irony here is twofold. At no point in the film are any words spoken—neither by parrot nor human. The much deeper irony, however, is the fact that this narrative parrot falls back on the very self-definition humanism has taken for itself, banking on the notion of the speaking-thus-rational animal: "The sounds we make are simultaneously our intentions and our life force. I speak therefore I am."[27] By invoking Descartes's *cogito,* the parrot betrays a nonhuman form of phonologocentrism, that is, the far-reaching dogmatic assumption Derrida began excavating in the 1960s, which assumes that reason and consciousness are reducible to phonetic signs or to speech-as-logos. This phonologocentrism is reinforced by some of the final passages of the film, where the parrot ponders the ways in which the word-concept "aspiration," which can mean both "breathing" and "hope," has informed world religions—from Pythagorean mysticism to Christian Pentecostalism

25. *Great Silence,* 6:18.
26. *Great Silence,* 8:00.
27. *Great Silence,* 10:06.

to Brahmin Hinduism. Religiosity is anthropologically predicated on vocal learning and the dogma of the larynx as offering access to the divine, an idea that mirrors humanist metaphysics, which assumes word-logos and mind to be tautological. In this instance, ironically, a parrot really is only parroting humans.

In retaining this phonologocentric bias, *The Great Silence* inadvertently points to some central disciplinary complications in ethology. There are at least two ways the discipline retains a similar phonologocentric bias. First (and most obviously), reporting on animal behavior is mediated by words, be they a conference talk or research paper. This means that nonlinguistic affects and forms of communication, which are abundantly shared by human and nonhuman animals, are unavoidably translated into a linguistic register. If ethological discourse presumes itself to be an adequate translation without loss, then the logocentric bias is evident. This is an area where art has a clear advantage over ethology, since artists deliver nonlinguistic affects and forms of communication through aesthetic experiences in ways that are less overpowered by the human linguistic register (that is, until it is written about by a critic or art historian, as in this very book). This is also why more popular ethological writings often take recourse to a certain degree of allusive and literary language (as well as photographs) to convey extralinguistic becomings, though even these will ultimately be overdetermined by the word. Second, and more consequential, is the relationship between scientific tractability and human language. If the verifiability of nonhuman minds runs along the path of speech (or even writing, if understood as purely phonetic)—as with speaking parrots or lexigram savvy bonobos whose symbols are vocalized with the help of a computer—then the assumption is clear: scientists have a more direct access to those types of nonhuman minds that can most easily enter the fold of the human world of symbols. These animals, it is assumed, have the capacity to attest to themselves through the phono-logos in ways other animals cannot. This is why Alex is a fascinating case study but also a limitation: the ethological breakthrough he rightly represents is nonetheless

restricted to an (ultimately circular) claim that speaking is, if not in a tautological relationship with mindedness and truth, then the closest or most transparent relationship we have to it.[28] What is missed are all the forms of language, communication, affectivity, and modes of becoming or being-with that no words can hope to fully encompass. Scientists may cry unprovable negative ontology here—but perhaps this is the best we can do in trying to access the great outdoors beyond what Bataille, in arguing for the world as deeply formless or *informe,* disparaged as the academic or mathematical "frock coat" of human reason. His definitional examples, incidentally, included spiders and earthworms.[29]

It should be clear that these ideas send us down the rabbit hole of language, cognition, and other minds that made Tinbergen balk at the prospect of studying the animal brain. It is much simpler to think that nonhumans cannot mean anything, properly speaking. For my present purposes, I point out the either/or that results from these observations: either speech and its phonetic mediation in writing are reducible to mind-concepts without remainder, and therefore offer the only way mind-concepts can be thought and expressed meaningfully, or, in a ethogrammatological reversal, speech is only one communicative medium for mind-concepts among others, which include gestures, nonphonetic vocalizations, somatic and affective collectives, and perhaps forms of nonhuman communication we have yet to decipher or even witness.[30]

28. Again, this grafts onto Derrida's deconstruction of expressive versus indicative signs. See also Dubreuil's insight that neuroscience verifies *différance* in thought. Dubreuil, *Intellective Space,* 7.

29. Georges Bataille, *Vision of Excess: Selected Writings, 1927–1939* (Minneapolis: University of Minnesota Press, 1996), 31.

30. This dislodging of the humanist tautology language = speech = mind would not necessarily entail a leveling. Human languages could still be understood as the most abstract and sophisticated, even if it must be admitted that this pride of place hinges on our own human understanding of "sophistication" as verified by our unmatched complexity and quantity of neuronal connections in the animal kingdom. This is a circular structure that is difficult to ignore or downplay and remains no less self-installed. For

There is every reason to think the latter is the more compelling starting point for appraising nonhuman alterity. After all, human speech is an evolutionary process only made possible by prelinguistic forms of communication based in affective meanings—recall Bateson's and Massumi's forms of play that presume semiosis. Our early hominid kin thought without words, as do all humans at the infant stage, which means concepts and cognition can and are embodied in unspoken ways—or better, spoken in unspoken ways, a paradoxical utterance that tellingly is only paradoxical in words.[31] Returning to Laurent Dubreuil's designation, there is an "intellective space" before, underneath, and all around spoken meanings.[32] This intellective space comprises a base "semanticism." This semanticism is not reducible to speech or even vocalizations. It is more capaciously described as "the proliferating attribute of mobile meanings" between self and environs.[33] So, rather than remaining "hypnotized by the power of our words"—saturated in their uncanny ability to code the real, a self-saturation that makes us think human logos amounts to meaning tout court—Dubreuil claims we should understand verbal language as "an extrapolation and a consolidation of semantic aptitudes" shared by many nonhuman animals.[34] He offers vervet monkeys as examples—specifically, their aptitude

a fascinating analysis of the nonhuman voice, especially cetacean voices, see Lynn Turner, "Voice," in *The Edinburgh Companion to Animal Studies,* ed. Lynn Turner, Undine Sellbach, and Ron Broglio, 518–32 (Edinburgh: Edinburgh University Press, 2018). For a similarly compelling analysis featuring a consideration of whale and parrot voices, see Dominic Pettman, *Sonic Intimacy: Voice, Species, Technics (or, How to Listen to the World)* (Stanford, Calif.: Stanford University Press, 2017), 51–63.

31. For an approach to these questions in the tradition of analytic philosophy, see José Luis Bermúdez, *Thinking without Words* (New York: Oxford University Press, 2003).

32. Dubreuil, *Intellective Space.*

33. Dubreuil, 35.

34. Dubreuil, 33.

for communication, for making associations, and for organizing the world around them.[35]

Dubreuil is careful to insist that this semanticism is not some universal code: "there is no language of thought (LOT), this fantastic universal 'mentalese' that particular idioms would duplicate."[36] He invites us to think more along the lines of a constellation of terrestrial meaning-making entities, which do not necessarily feed from the same semiotic trough. In this way, creaturely meanings or worldings represent idioms of the evolutionary real that can never be transparently known across some purported universal natural language reservoir—much in the way Jacques Derrida assessed literary translation to be necessarily impossible.[37] To perfectly translate French into English is to make it into English—and there can be no fixed, transcendental repository of Franco-Anglo tautological signifieds/referents. Similarly, to somehow translate the lived experience of a parrot into the lived experience of a human is to make another human, something equally impossible. In this way, the nonhuman English Alex spoke was, in part, idiomatically untranslatable into human English, which does not mean transspecies communication did not happen. We can often get the gist of a foreign idiom and use it as a tool, however clunkily and imperfectly, as did Alex. Those contact calls in the Rio Abajo Forest from *The Great Silence,* then, are idiomatic vocalizations of individuation, what we call "name," and what function as naming for parrots, if not in "name." Identifying another entity through a meaningful sound or gesture occurs beyond the coded parameters of human communication; we have simply added the extra conceptual step of giving the act a name.

All these observations bear on our many fantastical meeting points with extraterrestrial life. When aliens are presumed to speak in science fiction (usually in English), life and meaning remain

35. Dubreuil, 34–35.
36. Dubreuil, 36.
37. See Jacques Derrida, "Des Tours de Babel," in *Acts of Religion,* 104–33 (New York: Routledge, 2002).

phonologocentric and humanist. If, however, aliens communicate with earthlings by means other than speech, they open toward ethogrammatological and posthumanist conceptions of nonhuman life. Although written much earlier than his short story scripting *The Great Silence,* Chiang's short story "Story of Your Life," which was adapted as the film *Arrival* (dir. Denis Villeneuve, 2016), falls on the ethogrammatological side: the alien visitors, who appear in large glass tanks in hybrid form somewhere between elephant trunks and cephalopods, do not speak but write in a complex visual code via inky fluid.[38] These scenes find a wonderful echo in Derrida's hypothetical cuttlefish, which he sought to hold gently in his hands so that it might expel some ink. This ink, he maintains, would have the power of attesting to cephalopod interiority—it would not necessarily be *"the power to say* 'I' but the ipseity of being *able to be* or *able to do I,* even before any autoreferential utterance in a language."[39] In both cases—the theriomorphic aliens in *Arrival* and Derrida's cuttlefish—meaning manifests as a trace structure in an expanded ontological field of semanticism. They also both suggest that any conception of alien life beyond animality is something we cannot grasp—for what would communicable alien life be in science fiction films if not in the form of some humanoid or theriomorphic entity? It is as if establishing communication with alien life always presumes, at base, an ethological dimension, which may be telling for the ethogrammatological foundations of meaning and communication itself.

The analogy between alien and nonhuman animal life in *The Great Silence* and *Arrival* is not new. As the elemental media theorist John Durham Peters puts it, parrots, along with cetaceans and squid, have always been "preeminent fantasy animals."[40] These fantastical

38. For the short story in question, see Ted Chiang, "Story of Your Life," in *Story of Your Life and Others,* 91–146 (New York: Vintage Books, 2016).

39. Derrida, *Animal That Therefore I Am,* 92.

40. John Durham Peters, *The Marvelous Clouds: Toward a Philosophy of Elemental Media* (Chicago: University of Chicago Press, 2015), 69.

investments have often involved themes of the close encounter variety. Already in the 1950s, John C. Lilly, the flamboyant and controversial cetologist, is perhaps the person most associated with this analogy. His hit 1961 book *Man and Dolphin* begins with these lines: "within the next decade or two the human species will establish communication with another species: nonhuman, alien, possibly extraterrestrial, more probably marine; but definitely highly intelligent, perhaps even intellectual."[41] These ideas tap into a speculative captivation for extra and intraterrestrial intelligence during subsequent decades, which conflated large-brained mammals with alien life-forms.[42] Lilly even founded a "semisecret" society of SETI researchers with Carl Sagan named the Order of the Dolphins.[43] In 1960, he also opened his Communication Research Institute (CRI), situated on the island of Saint Thomas, only a stone's throw from Puerto Rico—the very same year the Arecibo Observatory was getting off the ground.[44]

Lilly, with the help of like-minded researchers (including a young Gregory Bateson, who would eventually head the CRI), controversially sought to speak with dolphins as a means of communicative preparation for what he was convinced would be eventual visitations from intelligent space aliens.[45] Like Allora and Calzadilla's *The Great Silence,* Lilly's focus on the vocal abilities of dolphins is an instance of phonologocentric prejudice. He assumed that communing with cetaceans (and eventually Martians) would involve human speech, leading Lilly to great lengths in attempting to establish lines of communication with his nonhuman subjects

41. John Cunningham Lilly, *Man and Dolphin* (Garden City, N.Y.: Doubleday, 1961), 11.

42. Peters, *Marvelous Clouds,* 75.

43. D. Graham Burnett, *The Sounding of the Whale: Science and Cetaceans in the Twentieth Century* (Chicago: University of Chicago Press, 2012), 612.

44. Burnett, 582. The Arecibo Observatory was built from 1960 to 1963.

45. Burnett, 573–74.

(early investigations in nonhuman primate language learning were similarly phonologocentric, such as Cathy and Keith Hayes's work with chimpanzees that led to so much controversy and setbacks for primate communication research[46]). His far-fetched and scientifically dubious experiments involved dropping acid and dosing the animals themselves with LSD to facilitate conversation.[47] Lilly also planned on using vocoders to translate dolphin vocalization into human speech. Again, this presumed a clean phonetic translation between dolphin and human language to be possible. This is attested to by a diagram published in 1967 depicting this elaborate contraption: the dolphin sounds would be relayed through a set of microphones, amplifiers, loudspeakers, and recording devices.[48] The crucial links in the vocoder's chain, however, are the boxes labeled "man-dolphin decoder" and "dolphin-man decoder." Needless to say, these presume a great deal about the translatability of nonhuman meaning into human speech—and vice versa—and that a universal code of language exists to be transformed and decoded into human speech without loss.

46. Beginning in 1951, the Hayes attempted to teach chimpanzee Vicki how to speak, by and large unsuccessfully. Herbert Terrence's work with chimpanzee Nim in the 1970s, by which Terrence concluded apes do not have grammar or concepts, in opposition to Beatrix and Allen Gardner's work with chimpanzee Washoe, had perhaps the most negative impact on ape language research. Dubreuil Laurent and Sue Savage-Rumbaugh, *Dialogues on the Human Ape* (Minneapolis: University of Minnesota Press, 2019), 208–9, 146–47.

47. Burnett, *Sounding of the Whale,* 617–19. Lilly began his career in military bioscience, which served instrumentalizing forms of "deconditioning" of the Cold War brainwashing kind, including the interrogative use of LSD. He was the inventor of the deprivation tank and sensory deprivation techniques that stemmed directly from his invasive brain experiments and cortical mapping on macaques and dolphins. Lilly was also involved in the CIA "artichoke" project, which would become the MKUltra project on which Naomi Klein reports in her 2007 book *Shock Doctrine.* This all demonstrates the much darker techniques opened up by ethological research in the twentieth century. See Burnett, 578–79.

48. See Burnett, 620.

Falling into scientific disrepute after his experiments with synthetic hallucinogens, as well as a notorious episode of human–dolphin eroticism in the tank involving one of his assistants, Margaret Howe,[49] Lilly later leaned toward new age spiritualism and made even more dubious claims further exceeding the rigors of science (including the claim that conversing with intelligent cetaceans will lead to a more peaceful postwar world). If I conclude this chapter with Lilly, then, it is not to offer him up as paragon of constructive deconditioning of animality that might push the constraints of science. As an ethological sophist, his example is nonetheless informative, since his pushing of the scientific envelope reveals some of its dogmas. Humanistic, phonologocentric presumption is only one. Another is taking recourse in a self-evident truth about nonhuman animals as conditioned by fabular beliefs that presume inferiority. In their review of *Man and Dolphin,* the marine biologists William N. and Margaret Tavolga criticized Lilly's unsound methods and fuzzy use of terminology. In doing so, they make a telling analogy between cetacean and avian mind:

> If "one two three" said with very poor intelligibility by a dolphin is indicative of the giant-brained animal's ability to speak, and therefore to learn language, what is to be said of a parrot's clear-cut, if bird-brained, "Polly wants a cracker"? Furthermore, if the parrot is then given a cracker, have we established communication with an alien species?[50]

This passage has it all—alienness; the assumption that speech and language are tautological; and the smug, automatic belief that parrots are "bird-brained." The latter, as self-evident analogical supplement serving to discount cognitive abilities, has since lost its grounding. From the perspective of a critical ethological aesthetics, however, we can be satisfied neither with killjoy scientism nor with

49. Bateson hired Howe, who would be central in Lilly's "chronic contact" experiments in 1964 and 1965, which included sexual contact. See Burnett, 612–17.

50. Quoted in Burnett, 591.

new age sophistry. Perhaps a deconstructive midway point—which would show how the killjoys and the new agers actually need each other in negative supplementation—is a strategic sophistry based in compelling speculation. Despite Lilly's humanist assumptions about the centrality of speech and vocalization, he does represent a proto-posthumanist position that envisions a Copernican revolution with respect to intelligence. Many of Lilly's outlandish claims have rightly been discarded, but some of his speculations remain compelling. His idea that dolphins perceive the world through sonar "vision," which allows them to see through things in ways humans cannot, might be persuasive.[51] Picking up on this thread in his *The Marvelous Clouds: Toward a Philosophy of Elemental Media,* which blends media studies with ethological research, Peters attempts to think through what it would be for a creature to experience the world and its others via porous sound waves, "an oxymoron for us, but perhaps mundane for dolphins."[52] Peter's cetacean phenomenology is just the sort of judicious speculation that is called for and is an exemplary attempt at stepping into nonhuman worlds.

51. Burnett, 595.

52. Peters, *Marvelous Clouds,* 69. I am greatly indebted to this book, especially its second chapter, and cannot recommend it enough as a multidisciplinary example of the type of critical ethological aesthetics I am advocating.

Step 2: Nonhuman Worlds (Entering Posthumanism)

DECONDITIONING ANIMALITY is critical for refreshing our collective understanding of nonhuman animals, yet the process risks sliding back into humanist gear when the inevitable moment of *reconditioning* retains human capacities as hierarchical measurement—be it cognition, sociability, language, or other qualia. While now ethologically democratized beyond the anthropropri-etary (in the sense that other creatures are understood to hold an evolutionary share, like phonologocentric parrots), this moment of reconditioning often safeguards the human animal as epitome. Peter Godfrey-Smith makes this point in his etho-philosophical study of cephalopods: "When we imagine the lives and experiences of other animals, we often wind up visualizing scaled-down versions of ourselves."[1] Many valuable ethological studies that successfully argue for a democratization of existential capacities hold this assumption, which tends to have a twofold effect: (1) nonhuman capacities that do not coincide with human capacities are elided, missed, or deemed intractable and (2) the *circularity* of this method, which entails humans imposing their own capacities as the measure for the living, is left uninspected. For this reason, even ethologists

1. Peter Godfrey-Smith, *Other Minds: The Octopus, the Sea, and the Deep Origins of Consciousness* (New York: Farrar, Straus, and Giroux, 2017), 10.

attuned to the newfound complexity of animal life can remain an-
thropocentric. The very concept of complexity itself is assumed to
be a fixed law of nature, rather than an operative concept relative to
human abilities and limits—yes, humans are complex creatures, but
only by decree arising from their own self-measured understanding
of said complexity. Even Heidegger, who was no stranger to con-
fronting the abyss of circularity, falls prey to its logic when claiming
only human *Dasein* sees the clearing of the "as such," all without
making note of the fact that it is a human who asserts this ability to
generalize the paragon of world making (should "as such" even be
anthroproprietary). Is this not ontology as self-fulfilling prophecy?

The pitfall here is no longer anthropomorphism pure and simple,
which falsely presumes a discrete humanity ready-made for project-
ing onto animality. From an ethologically posthumanist standpoint,
with a clear-eyed nontranscendental point of departure concerning
the immanence of life on earth, this purity of human separation from
animality is illusory. Instead, when a human capacity is projected
onto nonhuman life, it is based on a *difference from within animal-
ity itself.* Arguably, this projection is always a nonpure difference
of degree and not of kind. But even if we come to find (or rather
factishistically *produce*) a human quality that is ours and ours alone,
nothing authenticates this quality as our secure extraction point
from the creaturely field, barring some divine decree. The human
quality being projected from within animality will likely be deemed
more sophisticated, either in its relation to other animals or as a
discrete nonrelation within the creaturely field (again, should such
a quality exist). For even if recent studies show that grief, jealousy,
empathy, and so many other affective states are shared by numerous
nonhuman animals, these are often assumed to be impoverished
compared to their human versions.

There are circumstances where it might be wise to retain hu-
manist circularity when not simply in the service of holding indis-
criminate power over nonhuman animals. This is especially true
in light of urgent political struggles—the fight against neocolonial
aggression, gender discrimination, rampant misogyny and racism—

where a strategic essentialization of humanity might be necessary for the full recognition of certain humans. From a theoretical and methodological perspective, however, it is fruitful to suspend this circular ontology that relentlessly finds (or does not find) "scaled-down" versions of humans in nonhumans. This will facilitate a posthumanist democratization of life where the affective modes of the living are no longer considered vertically but as a constellation. It would no longer be assumed that other animals inevitably hold a feeble share of what humans possess most fully. It would champion neurodiversity in its different ecological contexts, tenors, and flavors.[2] Above all, it would open avenues for getting a glimpse into nonhuman worlds without disturbing the waters too much with our all-consuming presence. Freed from ourselves, we are freer to speculate on others.

Entering these speculative waters demands the sort of restricted sophistry for which I advocate in the introductory chapter. We need compelling narratives grounded in biological observation and methods that push toward forms of deduction exceeding the disciplinary comforts of a science like ethology—yet not going so far that the method falls into unconditional sophistry, which would only serve to mystify and fetishize other minds. It is instructive to begin with an example that seems to do both: Vilém Flusser's and Louis Bec's joint venture *Vampyroteuthis Infernalis* (1987). This speculative text ruminates on the vampire squid, which until very recently had never been seen alive in its environment. Flusser begins with known biological facts—taxonomy, anatomy, and so on—but gradually, the reader notes a shift into more speculative statements. On the whole, Flusser moves from tractable scientific observation to restricted sophistry to ultimately wild figurative uses of the vampire squid. Bec's drawings accompanying the text are in a classifying genre of taxonomy laying bare an organism's inner workings, which is

2. The notion that there might be different "flavors" of consciousness I borrow from Dubreuil and Savage-Rumbaugh. See Laurent and Savage-Rumbaugh, *Dialogues on the Human Ape,* 87–115.

peculiar in contrast to Flusser's philosophical flights of fancy yet also brings a certain aura of scientific respectability and objectivity to the project.

Flusser's speculations can be separated into two groups: conjectures based in evolutionary homology and metaphoric leaps based in speculative analogy. They are almost always porous, as conjectural homologies provide launching pads for speculative analogies. In her essay on Flusser's *Vampyroteuthis*, Melody Jue provides a thoughtful reading attentive to both. She interprets Flusser's fable as offering a set of figurative associations between squid and photography. Jue also posits that the ephemeral arts and politics of the vampire squid—movements and impressions that dissipate quickly in their watery media—presage our information economy: "society becomes vampyroteuthic as human-made media move into an aquatic paradigm of informatic 'flow' programmed to influence human behavior."[3] This sea creature, which, Flusser posits, can manipulate fleeting jets of ink and light up the abyss with its chromatophores (often with the intent of dissimulating or lying), metamorphizes the more dystopian aspects of our media regimes that dictate intersubjective flows of information verging on propaganda and manipulation. The vampire squid thus doubles as spectacle, which today analogizes quite nicely with the more nightmarish corners of cyberspace that have proven to be a far more tentacular pseudopresence than Flusser or even Guy Debord could have imagined.

Jue spends the bulk of her time on these speculative analogies in Flusser's text, yet she also points to some conjectural homologies. Flusser's great contribution to ethological art is his method of paranatural etho-phenomenology, which Jue describes as imagining "the vampire squid's phenomenological world from the complexity of its particularly evolved body, proprioceptive orientations, and the benthic conditions of its aquatic milieu (pressure, temperature, buoyancy)." Even in the ocean abyss, homologies between human

3. Melody Jue, "Vampire Squid Media," *Grey Room* 57 (2014): 92.

and nonhuman exist (body, eyes, skin, neuronal functions, and so forth) from which compelling conjectures can be grounded. For Jue, this offers a "milieu-specific philosophy," one that critiques the "terrestrial bias of philosophy and critical theory."[4] As she points out, we know far more today about this elusive cephalopod than we did at the time of Flusser's writing. It is therefore not surprising that Flusser got some things wrong. For example, the vampire squid is only one foot long, not twenty meters. Nonetheless, Flusser's work opens the door for more conjectural forms of ethology, which might be too adventurous for the methodological constraints of ethology proper, but not for aesthetic disciplines that admit more daring explorations of other minds—like poetry and visual practices. Conjectural homologies can supply the basis and morph into speculative analogies, giving us our best shot of approaching intractable phenomena in the world that would otherwise remain out of reach of the positivistic sciences. As Stacy Alaimo puts in in her essay on the speculative "unmooring" of terrestrial humanist knowledge, when making statements about deep blue animal alterities, "metonyms traverse trans-corporeal networks, while metaphors demand some kind of imaginative leap."[5]

Inside this constellation of creaturely life, not all transcorporeal relations are as distant as human and cephalopod. Flusser was fascinated by the para-evolutionary separation between vampire squid and us, which makes sense in light of his hierarchical understanding of objectivity that the "further removed a phenomenon is from its describer, the more objectifiable it is."[6] For Flusser, the more proximate a creature is to our own human creatureliness, the harder it is to be objective about it. This is because we cannot step

4. Jue, 85.

5. Stacy Alaimo, "Unmoor," in *Veer Ecology: A Companion for Environmental Thinking,* ed. Jeffrey Jerome Cohen and Lowell Duckert (Minneapolis: University of Minnesota Press, 2017), 409.

6. Vilém Flusser and Louis Bec, *Vampyroteuthis Infernalis* (Minneapolis: University of Minnesota Press, 2012), 16.

out of our animality—especially our mammality, and most especially our primatehood.[7] This would mean that, for us, anthropoids are among the most obscure creatures on the planet. In this regard, perhaps the most celebrated contemporary visual work involving a primate is Pierre Huyghe's *Untitled* (Human Mask) (2014).[8] The nineteen-minute film features Fukuchan, a long-tailed macaque dressed in a young girl's clothing, with a long black wig and a white mask covering her face. Huyghe first saw her in a viral YouTube video.[9] In this clip, Fukuchan appears in a restaurant near Tokyo interacting with customers, handing them hot towels and beverages. Alongside another macaque, Yat-Chen, she is the property of the restaurant owner, who began using her for customer service, no doubt as a novel attraction. While the humans clearly enjoy themselves, the monkey's experience of the situation is less than evident. For his turn, Huyghe arranged to film Fukuchan after hours in the same restaurant devoid of any human presence, aside from the film crew, which remains unseen (in this way, retaining Western scientific paradigms of observer/observed). He also replaced her mask with one of his own making based on the visual tradition of Noh theater—a graceful white mask in resin.

While *Untitled* (Human Mask) is by and large set in this empty restaurant, the film begins outdoors. With the slow, steady movement of a drone camera, we first travel along an urban landscape with nary a sign of life. This opening sequence is brief but gives the impression that the subsequent scenes in the restaurant are located somewhere among these desolate streets. This is not the case. The drone footage is from Fukushima post-2011 nuclear meltdown (this

7. Illuminatingly, as Agamben notes, "primate" was originally called "anthropomorphia." Agamben, *The Open*, 24.

8. Thanks to Marine Pariente and Marian Goodman Gallery for arranging my screening of *Untitled* (Human Mask).

9. The sex of the macaque is unclear. I will use "she" for the sake of convenience. The video can be found online: Doug Meet, "Fukuchan Monkey Restaurant," YouTube video, 4:01, https://www.youtube.com/watch?v=zS7QkjIKOxk.

is never made clear to the viewer; the work has neither spoken nor written narration). This false spatial continuity finds an echo in the work's temporal dimensions once the viewer finds Fukuchan sitting "alone" in the restaurant. If *Untitled* (Human Mask) seems to unfold in real time, its temporality is actually highly disjunctive. Huyghe filmed Fukuchan over the course of a couple days, seamlessly editing the results. Viewers are immersed in a collaged temporality, even if our experience of it cannot pick up on its alinear vectors. We have been worked over by the cinematic apparatus, which in this case might productively reveal that real time is only human existential time and not *time-in-the-real*. If this different temporality is not existential human time, then neither is it some purported nontime of animality (think of Bataille's eternally present conception of the animal as water-in-water). To envision creaturely life as either temporal/human or atemporal/nonhuman is clearly an impoverished binary. That said, entering another creature's sense of time and space is daunting. Cinematic time like Huyghe's might offer some oblique possibilities. For instance, episodic time. Or superimposed times. Or recursive time, which humans might share despite our forward-marching clocks. Or, considering that some animals see with more plentiful eyes than binocular vision, perhaps there are collaged modes of time. Or experiences of time that are unimaginable for us, which would mean that nonhuman times, like nonhuman languages, may be idiomatically untranslatable into human time—and, furthermore, that a universal creaturely time bank necessary for such translations does not exist. This is not to say that Fukuchan experiences space and time in these ways. As a fellow primate, she likely experiences her world in ways similar to us. I am only pointing to the inherent possibilities of speculating on nonhuman worlds through nonhuman aesthetic media—like drones, cameras, and microphones—which might disturb our all-consuming presence and human capacities all too often assumed to be paragons of the real.

From the start, then, *Untitled* (Human Mask) plunges the viewer into various zones of indeterminacy. First is *ocular* indeterminacy,

since the drone and cameras used in the work are nonhuman van-
tage points that supplement human vision—so seamlessly, in fact,
that they are barely noticed. Second is *ecological* indeterminacy,
which puts into speculative play the radioactive thresholds of life
and death in a disaster area like Fukushima. Third, and most cen-
tral to the work, is the indeterminacy between human viewer and
Fukuchan herself, whereby transspecies confusion blends iden-
tification and counter-identification. This zone of indeterminacy
is a concrete example of difference from within animality itself,
where humans are always both divergent and homologous with
respect to disparate nonhuman animals. This is even reflected in our
taxonomic practices—in this specific case, primate/primate (same-
ness) but also human/monkey (difference). This seems to trouble
our law of noncontradiction, as well as human narcissism, though
the contradiction evaporates with the realization that human dif-
ferences are immanent to animality. Whatever the case may be,
when we are confronted with this zone of indeterminacy between
human and nonhuman, a few things tend to happen. Sometimes
this indeterminacy is tacitly disavowed through ideologically load-
ed inferences and projections—be they innocence, wildness, pure
instinct, or simple blankness. In other words, it will be tamed in
overdeterminate difference. Sometimes the opposite happens, and
this indeterminacy will be deemed to be more indeterminate than
necessary. The nonhuman animal is then often understood to be
abyssal, which usually leads to overreaching skepticism or overly
cautious theoretical armature. Sometimes both take place at once, in
which case, nonhuman creatures will be interpreted as *both* abyssal
unknowns *and* securely knowable (usually pejoratively) entities,
depending on the need, convenience, or habit.[10]

I borrow "zone of indeterminacy" from Deleuze, who himself
did not seem to realize that the recognition of said indeterminacy

10. For an example of this in relation to Huyghe's *Untitled* (Human
Mask), see Jennifer Higgie, "One Take: Human Mask," *Frieze*, no. 168
(2015): 88–91.

depends on a secure point of differential *determinacy* to make any such determination. This oscillation between indeterminacy and determinacy, which can itself be indeterminate, might be somewhat understandable when it comes to creatures mysterious to us, such as cephalopods. What is strange in this instance, contrary to Flusser's assertion about objectivity, is that we know quite a lot about macaques. Representing a long history of human interaction, they are one of the most studied animals on the planet. Macaques have been received variously as pests, tourist attractions, performers, deities, companion species, and experimental subjects.[11] Their ground-up spinal cords were central to the story of the creation of the polio vaccine, beginning with their importation from India to the Puerto Rican islet of Cayo Santiago in 1939 (in yet another connection with the Caribbean archipelago).[12] Returning once more to John C. Lilly, before he turned his attention to bottle-nosed dolphins as his favorite experimental subjects in tanks, we find him electrically stimulating live macaque brains to induce a cortical mapping of behavior—notably feelings of fear or pleasure.[13] Less macabre, macaques have played a foundational role in ethology—specifically, Japanese primatology, which Donna Haraway argues marks the origin of postwar primatology. Anticipating *Untitled* (Human Mask) from the late 1980s, Haraway makes an analogy with Japanese theater traditions: "Japanese monkeys might be viewed as actors in a Kabuki drama or Noh performance."[14] What she means by this is that, in contrast to Western scientific practices hoping to pry open and fully reveal natural and primitive nature, Japanese primatologists understood their subjects as practitioners of sociocultural dissimulation: "their stylized social gestures and intricate rule-

11. See Holly Dugan and Scott Maisano, "Ape," in Cohen and Duckert, *Veer Ecology*, 355–76.

12. See Neel Ahuja, *Biosecurities: Disease Interventions, Empire, and the Government of Species* (Durham, N.C.: Duke University Press, 2016), 101–31.

13. Burnett, *Sounding of the Whale*, 565–66.

14. Haraway, *Primate Visions*, 245.

ordered lives are like dramatic masks that necessarily both conceal and reveal complex cultural meanings about what it means to be simultaneously social, indigenous, and individual for Japanese observers."[15] Though Haraway dislikes the term, this acknowledgment of primatehood gets to the core of a posthumanist ethology.

If Huyghe's Noh mask hides something, then what it conceals is not some innocent state of nature, some impassable abyss, and certainly not a creature without any face at all, as reactionary humanists might have it. Instead, the resin mask hides a flesh-and-blood mask that also divulges and conceals certain things about itself. In an odd twist, Huyghe's uncanny mask is actually revealing. Without it, worn tropes of an innocent, impassably abyssal, or faceless animality might continue to be projected unchecked, even with a macaque staring right back at the human viewer. In negative revelation, the humanoid mask disturbs dogmatic assumptions about the animal on the other side by its obdurate deflection while providing a blank screen for the simultaneous thwarting and revealing of human projections that obscure creaturely life. Were Fukuchan to be unmasked, her interiority would not be fully revealed, any more than human faces reveal their depths, even when supplemented with symbolic languages. Instead, the mask underscores something fundamental about what is likely a panoply of multispecies, intersubjective, and interpersonal possibilities on this planet: the oscillation between knowability and unknowability. As Haraway puts it, "masks cannot be stripped away to reveal the truth; rather the mask is a figure of the two-sidedness of the structure of life, person, and society."[16] Without this socionatural play between knowability and unknowability, of masks going all the way down, revealing and concealing along the way, we would be faced with either full intersubjective presence (which would only collapse into a singularity that undoes any and all relations) or pure unrecognizability (in which case, other life-forms

15. Haraway.
16. Haraway, 246.

would be purely alien—and, consequentially, completely unseen or missed). This is why indeterminacy needs determinacy. Face-to-face encounters are predicated simultaneously on meanings that get through and those that never can—both bridges and abysses—and this does not even mention all the ways in which intersubjective relations happen beyond the face. What is more, this dynamic is likely baked into the evolutionary real, which would mean there is nothing to reveal when what is sought after is, in fact, not hidden but untouchable in itself: when the full truth and nothing but the truth is its intractability and no amount of opening or imaging can get to it—say, consciousness, both human and nonhuman. This is no longer skepticism pure and simple, since not having full access to other minds becomes a positive knowledge about the real and the teeming creatures that walk, crawl, fly, swim, and lurk inside it. There is nothing to sneak up on; we are there already.

If, as the implied irony of Huyghe's title suggests, the mask stands in for the ostensible obfuscation of anthropomorphism, the lesson of Japanese primatology is that the human face and its affects should be the point of departure for the animal sciences. Haraway examines the different possibilities that arise from this, beginning with Kinji Imanishi's groundbreaking work. Encouraging his fellow prima-tologists to enter into multispecies identification with Japanese macaques, he employed what can be described as an ethnographic approach to nonhuman communities by setting up provisions for his subjects and stressing collective and long-term study. The pri-matologist Kawai Masao even coined the term *kyokan,* a sympathet-ic method that translates to "feel-one," which encompasses "the particular method and attitude resulting from feelings of mutual relations, personal attachment, and shared life."[17] In other words, Japanese primatology works from the premise that intersubjectiv-ity is, in fact, an objective feature of the world, which flies in the face of Western scientific paradigms maintaining subject–object

17. Haraway, 251–52.

separation.[18] In this way, Japanese primatology was posthumanist from the start. No wonder it was the first to observe and confirm nonhuman culture—that is, the shared knowledge of how to wash sweet potatoes. As Haraway would put it, the world is filled with naturecultures—neither primitivist innocence nor impassable abysses but variegated levels of kin.

Returning to Huyghe's *Untitled* (Human Mask), Fukuchan should now seem far less alien. We can speculate about her existence through sound homologies that provide the basis for compelling analogies. To do so, we have to think more like a Japanese primatologist: a mammal and primate (we human viewers) is watching a fellow mammal and primate (Fukuchan), a sameness that often gets erased by the simultaneously real differences from within these categories, namely, a *Homo sapiens* watching a macaque. This encounter is like a corporeal Venn diagram forming the basis for posthumanist modes of viewership:[19] identifying with nonhuman life from which we share a foundation, and refusing the illusory sovereign position that disavows sameness by myopically focusing on purportedly transcendental differences. Oddly enough, from within this field of creaturely immanence, we have always been as much nonhuman as human. Many of our affective inferences with members of our own species are based in animality, and the nonhuman in us has always been available for deducing judicious meanings in other species. This includes the ability to make logical

18. Objectivity is never so simple. For a brilliant history and understanding of objectivity as nonstandardizable, see Lorraine Daston and Peter Galison, *Objectivity* (New York: Zone Books, 2018).

19. When taking into consideration the great variety of animal life, this Venn diagram thought experiment would have to perform some serious visual gymnastics of multiplying overlapping and nonoverlapping centers. The *anthro* is implicated and grounded in proliferating strata of unwieldy centrisms, including apecentrism, primatocentrism, mammalocentrism, and ultimately theriocentrism. Tristan Garcia holds a similar hypothetical visualization of multiplying identifications and nonidentifications through his use of "calques," or overhead transparency sheets, which can be superimposed and sequenced on a light projector. See Garcia, *Nous* (Paris: Bernard Grasset, 2018).

deductions, as well as inferring feelings and moods, which Western ethology continues to deem intractably off-limits.

The prevailing moods in *Untitled* (Human Mask) are contemplative, bored, restless, and anxious. Fukuchan first appears seated in the hazy stillness of the empty restaurant. She quietly inspects her wig, caressing its strands with fingers. She plays with her fingernails. She swings her leg back and forth from off her perch. This hair playing, nail inspecting, and leg swinging might attest to the simple pleasures of movement, but they are more likely symptomatic of an absentminded existential register—either habitual ticks out of malaise or side manners that often supplement contemplation (as Heidegger realized, the dividing line between contemplation and boredom is a thin one). Fukuchan will also suddenly get up and run through the restaurant, opening and closing the refrigerator, for instance, or install herself at the longer wooden table used by dining customers. Again, these movements might be read as the simple pleasures of movement within the possibilities and limitations of her space, or they could be the release of nervous or weary energy. Toward the end of the film, Fukuchan appears more visibly upset. She impetuously overturns a bottle on the table and runs into what appears to be a storage room, where she stares intently at the ceiling. During this scene, Huyghe interposes closeup shots of writhing maggots underneath clear plastic food wrappings and a cockroach scurrying across the floor, adding to the effect of postapocalyptic abandon. It is never clear what disturbs Fukuchan overhead. Since the final shots of *Untitled* (Human Mask) find a rainstorm opening up over the restaurant, maybe it is the change in weather that elicits anxiety (and since the rain comes some moments after her seemingly alarmed state, it is as if she feels the rain coming before the viewer, though this could be chalked up to chronological editing of nonchronological events). Either way, Fukuchan's mask is visibly wet during the very final scene, where the viewer finally gains a modicum of access to her face: behind the open eye slits of the mask, Huyghe's closeup shot reveals quick, darting, and searching eyes looking directly at the camera.

Much could be made about the way I have just described Fukuchan. Handedness, captivation, boredom, anxiety—this is all well-trodden territory for a Heideggerian reading of the animal and its recent cogent critiques.[20] At minimum, these modalities point to a lived importance. After all, handling things with your fingers, reflecting, being bored or anxious, all of these make no sense outside some sort of self-awareness or, why not, personhood. This is the case even in the most modest evolutionary explanations that find these feelings to have had adaptive benefits. When speaking to Fukuchan's self-awareness in her essay on *Untitled* (Human Mask), Jennifer Higgie makes a seemingly uncomplicated statement, which turns out to be quite complicated indeed. After affirming (wrongly) that humans are the only animals that habitually practice deceit, and that we are the only ones who can deceive ourselves (how would this claim even be verifiable in nonhumans?), Higgie proffers the non-human as living in direct self-simplicity: "It knows it's a monkey."[21] This is a striking claim. It would mean not only that Fukuchan has a sense of self and an understanding of her own kin but, additionally, that she holds the classifying concept of "monkey" as such. The first two parts of this claim are almost certainly true—the second almost certainly not.

As far as we know, macaques do not make taxonomic differentiations as we have seen fit in our history of natural sciences—that this is a "macaque," a type of "monkey," that we are "humans," a type of "primate," or that this is a "conifer," a type of "tree," and so on. This does not mean that they do not communicate in their own embedded semanticisms, which may very well include signifying types.[22] And certainly this does not amount to saying ma-

20. For a helpful overview of the debate dealing with both Heidegger and Agamben, see Matthew Calarco, *Zoographies: The Question of the Animal from Heidegger to Derrida* (New York: Columbia University Press, 2008).

21. Higgie, "One Take: Human Mask."

22. For a sympathetic overview of nonhuman languages, see Nathan H. Lents, *Not So Different: Finding Human Nature in Animals* (New York: Columbia University Press, 2018), 272–312.

caques do not hold concepts or perform differentiations at all. They must—otherwise concepts and differentiations would only come into existence ex nihilo with the advent of their human classifying signs, a far-fetched conjecture that puts the semiotic cart before the minded horse. Having no need for "monkey" or "concept," a being like Fukuchan nonetheless lives as the substrate for these signs, living and breathing, recognizing her kin, performing logical leaps of differentiation and imagination, and making and communicating the meaning of her world through a mind-body attuned to the objects and bodies around her. This entity with limbs and a brain largely homologous to ours found herself embedded with a film crew in a restaurant and likely made the following conceptual differentiations: *like me these moving presences make sounds, have eyes and limbs, and seem to recognize me and my ability to perform certain feats—while other entities in the world, like these green foliaged structures outside the window I'd like to climb on, or these writhing maggots, or this glass object I just pulled from the fridge, do not have these abilities in relation to my own and do not recognize me.* These are words used in a judicious though highly paradoxical attempt to access thinking without words. As humans, we may be able to perform a similar asymbolic *epoché* on ourselves to attune to the unworded thoughts and affects that course through us all the time, which then get mediated in speech or immediately dissolved into living-dead script (which explains the italicization of my worded attempt earlier to channel macaque thinking). In this way, it is not that we cannot understand the nonhuman. Instead, reiterating Laurent Dubreuil's suggestive diagnosis, it is that we are hypnotized by our own words that mystify ourselves-outside-our-words: "we say more than we think; we think more than we say."[23] Dubreuil's rich opening theoretical two-step from his *The Intellective Space* suggests that our languages exceed our ability to fully account for their shared symbolic powers, while not losing sight of the ways in

23. Dubreuil, *Intellective Space*, 3.

which we inhabit a semantic field beyond the symbolic. Recognizing this expanded field of semanticism may allow us to access, however obliquely, nonhuman semantic fields. Dubreuil's opening lines also make room for a wonderful turning of the tables: instead of deeming asymbolic forms of life as deficient, is it not instead our symbols, however powerful and useful for us, that have proven to be inadequate for the job of fully encompassing the real, especially nonhuman experiences of it?

Some fascinating insights arise from all this, perhaps the most fascinating being the utter decentering of the concept of human, which may not be so anthroproprietary after all. In their compelling set of interviews coupling primatology and philosophy, Dubreuil and Sue Savage-Rumbaugh debate this possibility, prying open a considerable distance between *the lived experience of being human* and the word *human*. After Sue Savage-Rumbaugh mulls over the question whether chimpanzees and bonobos make us–them distinctions, Dubreuil suggests that there "is no reason to consider that discourse would be the only basis for producing the difference between us and non-us." This means that adiscursive nonhumans might also hold performative group conceptions demarcating their own lived importance in the world differentially from others.[24] Furthermore, this might mean that our marking-off term *human,* which has been culturally and historically variable, is a symbolic placeholder for a more general group feeling of lived importance. In this way, if nonhuman groups could speak our symbolic language, maybe they would nominate themselves as the real "humans" and not, in fact, as "animals." Savage-Rumbaugh's wonderful observation about bonobos Kanzi and Panbanisha is telling in this regard: "By the time Kanzi and Panbanisha were grown, I couldn't possibly accept the definition that they were animals, and I couldn't stand it when people called them 'animals' in their presence. *They couldn't stand it either.*"[25] It may then be that the human–animal divide is

24. Laurent and Savage-Rumbaugh, *Dialogues on the Human Ape,* 32.
25. Laurent and Savage-Rumbaugh, 23, my emphasis.

operative outside our species and that *human* is a shifter pointing to a sense of lived importance shared by at least some nonhuman animals, without having any need for the symbol "human" itself. In other words, if *human* and, indeed, *person* are signs pointing to a sense of differential existence in the world, then the possibility always exists that this modality, beyond or underneath these symbols, is felt, shared, and lived by any number of nonhumans in similar though likely variegated ways.

The result is that the human is not first and foremost a taxonomic category but a general mood of self-lived importance, most likely grounded in group dynamics of mutual identification, an existential mood of demarcation in the world, shared horizontally within animality. This aligns with non-Western etho-epistemologies, like the Amerindian "perspectival" and "multinatural" traditions that inform Eduardo Viveiros de Castro in his *Cannibal Metaphysics*. There de Castro describes the "perspectival inversions" that run through the natural world, notably in the creaturely realm:

> Why is it that animals see themselves as humans? Precisely because we humans see them as animals, while seeing ourselves as humans. Peccaries cannot see themselves as peccaries (or, who knows, speculate on the fact that humans and other beings are peccaries underneath the garb specific to them) because this is the way they are viewed by humans. If humans regard themselves as humans and are seen as nonhumans, as animals or spirits, by nonhumans, then animals should necessarily see themselves as humans.[26]

Some of Huyghe's installations, like his contribution to Documenta 13 (2012) and his 2014 retrospective at the Los Angeles County Museum of Art, included an Ibizan hound named "Human" who was free to roam the grounds or gallery with a right front leg painted a striking shade of pink. Although this nomination might be read as facile irony or even a debasing gesture, from the preceding analysis, it might actually have a constructive, denotative quality of this dog's

26. Eduardo Viveiros de Castro, *Cannibal Metaphysics,* trans. Peter Skafish (Minneapolis, Minn.: Univocal, 2017), 69.

lived importance in relation to the interesting others around her, whom she might interpret as variably friendly nonhumans. She represents a deregulation of the anthropropriety notion of the human as a broader sense of lived importance of which the code word *human* has so long dissimulated. It should be stressed, however, that smooth spaces exist between established species barriers. It is likely that companion species understand themselves to be embedded as variant "humans" among their human kin—perhaps dogs like Human interpret their largely hairless creaturely companions as differently abled humans. But we can go further, since in some ways, this posthumanist conception of the human as rhizomatically active in the other minds populating our planet retains a liberal and neuronormative conception of lived importance. It is possible, though certainly even more speculative and difficult to verify, that nonhumans whose cognitive structures are quite different from ours—usually deemed less complex, with fewer neuronal connections—also have a sense of lived importance to which we have far less access, since it is so unlike the "human" placeholder of lived importance we share within our primatocentric and mammaliocentric positions within the evolutionary real.

With the help of Fukuchan, I have brushed up against the limits of human symbolic language and the evolutionary real from which human minds have immanently symbolized concepts over and above a phenomenological existence we share with many other nonhuman animals. I have posited that many animals hold concepts in unworded (or differently worded) neurocorporeal ways. These may nonetheless be communicated via nonhuman semanticism—gestures, calls, looks, or smells. It is also possible that some of these meanings are only known solipsistically without any way of externalizing or translating them (which, again, is likely the case for much of human intersubjectivity). It may equally be possible that their understandableness can only be known from within a nonhuman group or swarm and therefore completely barred from tractable human observation and study. Speaking in speculative realist terms, all this would mean that we are not the sole correlators on this planet. The

general stance of Quentin Meillassoux's speculative realism, which is variably shared by other recent forms of Continental realisms, such as Graham Harman's object-oriented ontology, is to critique the Kantian transcendental human subject who is said only to have access to the world through human mindedness and categories. This is the lot of "correlationism," where we are forever barred from the absolute—or, using another of Meillassoux's terms, the "great outdoors"—since our mindedness always gets in our own way. Despite its impressive speculative gymnastics, what is interesting here is that speculative realism and all other philosophical endeavors to exit the correlationist circle so as to arrive at the real in-itself remain within a modernist paradigm of objectivity and autonomy: the desire for total access to the absolute in philosophical panoptic sovereignty.

Dealing properly with these ideas would require another book altogether, one recognizing the many internal differences of the realist turn in Continental thought. I do, however, want to tentatively introduce the creaturely into this debate. An attentive reader of Meillassoux's touchstone *After Finitude,* for example, will note a frequent slippage in the text within the category of earthlings: we find "terrestrial life," "living creatures," "human species," "humanity," "consciousness," and "thought," all of which overlap but are not necessarily reducible to each other.[27] Are nonhuman animals correlationists? Quasi- or inferior correlationists? Do they not correlate at all? And does that fact that many nonhumans perform arithmetic trouble Meillassoux's ultimate claim that humans have access to the absolute through mathematics? The nonhuman creature poses a dizzying array of problems for speculative realism and any flat ontology that whisks away the creaturely to be like any other entity in the real. By virtue of their stubborn parahuman existence, nonhuman animals seem to impose a deconstruction of/

27. Quentin Meillassoux, *After Finitude: An Essay on the Necessity of Contingency,* trans. Ray Brassier (New York: Continuum, 2008).

in the real of the correlationism–noncorrelationism binary. For are these really the only two options available? Might we not instead understand the world as comprising a multitude of *correlationisms*? Correlationism in the singular is certainly wrongheaded because of its anthropocentric myopia—and yet, arguing for pure noncorrelationism, should such a thing be possible, risks skipping over a panoply of nonhuman creaturely worldings. For a speculative realist, the problem with the preceding argument is that I have performed a generalized Kantianism of the living, where now even nonhumans correlate with the world.[28] I have simply widened the correlationist circle and made it posthumanist (still, I would argue that this is no longer in fact a circle but a constellation of different correlationisms, fragmentary and intersective). This would mean that, like us, nonhuman animals are cut off from the great outdoors, in contrast to Rilke's poetic notion of animals having full access to the Open. If the poet were alive today, he might say that the *kreatur* is the original speculative realist in its uncorrelated and unmediated access to the world, an idea that now can only smack of projected, primitivist innocence.

Again, I do not have the space here to entertain the complex issues that arise from taking the creaturely seriously with respect to the multifaceted debates in speculative realism, but there is one final observation that should interest philosophers, ethologists, art historians, and artists alike: let us hypothesize that we humans are only one correlator among many; would this mean that there is *one* world or *many*? If the former, then one absolute exists with which we and all other creatures correlate in a unified great outdoors (though this begs the question of who authenticates this One). This would be akin to the universal language of thought discussed in the previous chapter, though now on a more material plane of the real.

28. Though I stop short of saying that nonanimal nonhumans also correlate, as Graham Harman does in his often-repeated example of fire correlating with cotton in the sense that they never touch—perhaps it does, but only for a third-party conscious creature who can witness this relation.

Consequentially, all experiences on this planet would ultimate-
ly be understood as phenomenal idioms that can be translated as
particular units of experience of a universal world. While we may
correlate with the world differently than other nonhuman animals,
human and nonhuman animals nonetheless correlate with the same
absolute. If, instead, there are as many worlds as there are types
of correlators, then there is no unified great outdoors. In this sce-
nario, every creature is a unique point of worldly overture, which
is why Derrida claimed that there is no world, only islands. Here
we enter the speculative domain of Jakob von Uexküll's *Foray into
the Worlds of Animals and Humans* or, more recently, Cary Wolfe's
theory of worldly islands built on his reading of Jacques Derrida's
Beast and the Sovereign lectures.[29] All experiences on this planet
would ultimately be understood as phenomenal idioms that cannot
be translated as particular experiences of a universal world; the
world is instead made up of only a profusion of different partic-
ular worldings. No world, only worlds. I certainly will not settle
on one side or the other in what is likely an unsettleable debate,
but returning to Huyghe's *Untitled* (Human Mask), let me just say
that, like us, Fukuchan is part of the real that moves and correlates
from within it. What is the world to her? How does she correlate
with it? Taking recourse once more to a posthumanist ethology, she
correlates in ways that are likely simultaneously alike and different
from us. The answer may be a deconstructive midpoint: there is
both a world and many worlds.

In his essay on *Untitled* (Human Mask), Bertrand Dommergue pos-
its that Huyghe's film offers an end-of-the-world scenario in which
humans have become extinct and Fukuchan is the last monkey—
perhaps even the last living thing—on earth.[30] Dommergue's essay

29. See Cary Wolfe, "Of Ecology, Immunity, and Islands," in
Posthumous Life: Theorizing beyond the Posthuman, ed. Jami Weinstein and
Claire Colebrook, 137–52 (New York: Columbia University Press, 2017).

30. Bertrand Dommergue, "Human mask ou le dernier singe: à propos
d'une vidéo de Pierre Huyghe," *Ligeia* 1, no. 145–48 (2016): 57–60.

is framed along traditional lines that presuppose a determinacy between human and animal, something Huyghe's film does so much to suspend and destabilize. Rather than speculating more deeply on what the world without us would mean for Fukuchan, Dommergue maintains our all-consuming presence in the negative by claiming that Fukuchan is more or less aimless without her humans and unable to return to a natural state of animality (hence also presupposing a determinacy between culture and nature, which Huyghe's film also does so much to suspend and destabilize). Nonetheless, Dommergue's thought experiment is fruitful. For one, Fukuchan would represent a form of *present-tense* ancestrality. Here would be, on-screen, a minded entity in the world posterior to any human mindedness, effectively giving us an impossible glimpse of the world anterior to any human correlation. When Meillassoux describes ancestrality as "any reality anterior to the emergence of the human species—or even anterior to every recognized form of life on earth,"[31] Fukuchan can stand in for the creaturely slippage *after* the pure mind-independent (not even) nothing of the absolute real, but *before* the mind-dependent reality of human emergence and correlation that it is argued masks access to the absolute (even though, of course, Fukuchan is a contemporaneous creature, fully herself, and not stalled on a ladder of life with humans looking down from the top). It should be noted, once more, that Meillassoux's text presents an instability about mind-dependent reality—at times, it is restricted to the human, while at others, it is attributed more capaciously to the creaturely. The hyphen in Meillassoux's preceding definition of the ancestral is thus quite loaded.

In fact, there are at least three possible worlds when considering ancestrality: a time before any correlates at all (a precreaturely time), a time of nonhuman correlates but prehuman minds (a creaturely time, though not yet human creaturely time), and a time of human correlates (the present, if not likely the far future). That mid-

31. Meillassoux, *After Finitude*, 10.

dle time is speculative ethology's time. It has to be admitted that we can imagine what the world was like for the dinosaurs whose fossils litter geological strata today far better than precreaturely objects; rocks and plants do not have neurological structures and did not become the birds flying by our windows. Admittedly, the access to dinosaur mind is highly speculative and forever unverifiable—but nonetheless, there is some retroactive theoretical purchase. At the very least, we can say that this triceratops was embodied and had some sort of rapport with the world, even if we cannot know the *how* of its ancestral life. The same cannot be said about Theia—the ancient planet that collided with Earth, likely forming our moon—nor the elementary particles created much further back at the big bang (barring some divine observer whose faculties of experience would have to be, at bottom, creaturely). Compared to the mental exercise of what it might mean to be an electron, being a bat starts to seem far more bridgeable. Even if we agree with Meillassoux that the human is a distinct creature with mathematical analyses providing access to absolute ancestrality, thus making objective claims about a precreaturely time, it would still behoof a speculative realist to attend to the speculative ethologies that might give us even richer access once creatures arrived on the planetary scene.[32]

What is further interesting about Dommergue's thought experiment is that, at its heart, it is a pure impossibility. This is not only in the paradoxical positing of our own extinct viewership.

32. On the other side of the argument, Slavoj Žižek rejects any speculative horizon beyond the human subject and maintains that thinking ancestrality is necessarily a retroactive illumination. Here, too, ethological speculation would benefit the argument, which remains all-too-humanist. For Žižek, the human is an existential aberration, that impossible object that is also subject—from substance (S) to subject (\$). Of course, this impossible gap of thought that emerged from pure unthought substance is unlikely to have arisen ex nihilo, which means either there is a prehuman creaturely subject that made it all possible (which admittedly kicks that can down the road of consciousness and subjectivity) or this theory of subjectivity needs to be scrapped altogether. See Slavoj Žižek, *Less than Nothing* (London: Verso, 2012), 625–47.

Recalling Jean-Luc Nancy, it would require Fukuchan to be absolutely alone, which is logically impossible: "to be absolutely alone, it is not enough that I be so; I must be alone being alone—and this of course is contradictory."[33] But more practically, how could a macaque ever verify or know that it is the last living thing on earth? Or, for that matter, how could even the most technologically extended human know this? It is an impossible knowledge. Yet the far more interesting impossibility here is less logical than logistical at the level of ethological care. As Karl Steel has eloquently written about the history of isolation experiments and feral children, "nothing does well on its own."[34] It is catastrophic, as Harry Harlow found out in his needless deprivation experiments on macaques. The innovation of Steel's revisiting these stories, which have fascinated the European imagination for so long, is to underscore the fundamentals of creaturely caring that apply to human and nonhuman, even in multispecies negotiation. Fukuchan starts to look like a feral child in reverse: raised, not in the wild by wolves, but in a restaurant by humans. However different, both scenarios tellingly demand attunement, attention, and care—in other words, meaningful others.

Finally, returning one last time to Dommergue's text on *Untitled* (Human Mask), he poses a fascinating question: why does Fukuchan not simply unfetter herself from mask and clothing? He seems disappointed that this does not happen (though it is possible that these moments were edited out, especially the mask, which must have felt new to her). Leaving aside the assumption that she in fact does feel alone (after all, the film crew is there, as is the cat I have not yet mentioned, an interesting other Dommergue seems to miss), this leads to a complex set of questions: Does she feel at home? And if so, where is this feeling localized? Does ideology extend into the non-

33. Jean-Luc Nancy, *The Inoperative Community*, trans. Peter Connor, Lisa Garbus, Michael Holland, and Simona Sawhney (Minneapolis: University of Minnesota Press, 2012), 4.

34. Karl Steel, *How Not to Make a Human: Pets, Feral Children, Worms, Sky Burial, Oysters* (Minneapolis: University of Minnesota Press, 2020), 62.

human realm? Has something been beaten into her? Ana Teixeira Pinto makes an important point about this and Fukuchan's kin that cuts through the speculation in which this chapter has indulged: "Bred in captivity or captured as infants, the monkeys undergo a grueling training process. To strengthen their hind legs they are often hung by the neck with both hands tied up for weeks on end, until they finally acquire a human-like posture, learning to handle props and perform human chores."[35] Here the question of power enters the picture, as does the use of nonhuman supernormality for darker ends. With this, the time of pure speculation is over. We now need the courage to make ethicopolitical claims about creaturely life by building on the ontological domain, without becoming resigned to its enervating and rationalizing temptations of skepticism and aporia—thereby entering the zoopolitical.

35. Ana Teixeira Pinto, "The Post-human Animal: Was Hat Es Mit All Den Tieren in Der Aktuellen Kunst Auf Sich?/What's Behind the Proliferation of Animlas in Recent Artworks?," *Frieze d/e*, no. 19 (2015): 75–76.

Step 3: Zoopolitics (A Political Critical Ethology)

IN HIS METICULOUS HISTORY of how whales went from hunted floating oil barrels to the most loved and protected of megafauna, D Graham Burnett comes across two macabre and thankfully unrealized plans for cetacean aquaculture just before the ecopolitical turn in their favor in the 1960s. One involved a factory ship inspired by sausage machine technology that would have processed whales completely out at sea—slicing and separating unusable from usable parts fit for commodification (like perfume and gasoline). The other involved the conversion of Pacific atolls into vast whale farms filled with "captive rorquals fattened on artificial plankton blooms"—a plan arriving complete with conservational arguments from cynicism that pits the exploitation of bodies against the resulting lifting of them out of endangerment by mass breeding.[1] These proposals represent the two logics of intensive agriculture in the twentieth and twenty-first centuries: the factory farm and the concentrated feed lot. Coupling the efficiency and speed of processing farmed bodies with the augmentation of the scalability of carceral confinement, these have had devastating consequences and should be understood as a planetary historical injury.

That these projects did not come to pass is a reflection of the conjoined success of ethological knowledge and the messy proce-

1. Burnett, *Sounding of the Whale,* 522–24.

dures of political will. This was still, presumably, a time when the majority of politicians in the United States listened to scientists. Burnett demonstrates how ethology, in the form of cetology, played a crucial role. It is arguable the whales' success he traces is due not only to their minded proximity to humans but also to their alienness—mysterious underwater songs and big-brained aquatic intelligence. For while there have been comparable ethological breakthroughs regarding more mundane animals—cows, pigs, and chickens—public disgust and ecopolitical will have yet to reach similar critical mass. Though animal welfare and rights movements have gained a modicum of public traction, especially in relating the problem to global warming, at no point in human history has animal exploitation been as intensive as now. Lamentably, it is only accelerating. Perhaps this is due to the timeless veneer that accompanies nonhuman domestication, at least in those societies habituated to it. Had whale consumption been a long-established part of the majority of Western human societies and economies—as indeed it is in certain places in the world, such as Japan and Norway—cetaceans might have remained exploited even after novel and ethological discoveries retroactively reassessed their minds and forms of being. Here, then, we reach the limits of ethological research: it is only with great difficulty that new knowledge about nonhuman animals will actually erode entrenched traditions, symbols, and economic activities that depend on their exploitation. Tweaking Upton Sinclair's well-known truism, we might say that it is hard to get humans to understand something the more their profits and pleasures depend on their not understanding it. Admittedly, this phrase is all too faithful to the enlightenment program and has difficulty dealing with its two very powerful nemeses: ignorance and cynicism. This is part and parcel of the dialectic of *entitlement* that has accompanied historical "progress," especially capitalist "progress," which means especially Western colonial and imperial "progress."[2] These notions

2. One day I plan on writing a book called *Dialectic of Entitlement*, collaboratively, I hope, with a critical animal studies scholar outside my

of progress continue to be widely predicated on the subordination of nature in favor of gross domestic product in what is increasingly shared as a planetary neocolonialism.

Once deconditioned as no longer dumb brutes or mindless machines, and once attempts have been made to enter their minds through speculative and sympathetic imaginings, and yet still nonhuman animals remain prey to widespread human violence and immiseration, something more is needed. Ethology is not enough. Social, political, and aesthetic coalitions have to be forged to act alongside its knowledge. What is needed is a political critical ethology, one that sheds ethology's past dubious political associations with social engineering, state biology, and any other nonplastic reductions of life. A number of progressive avenues might be envisioned, but here I offer three and elaborate on them with examples. (1) We need an ecopolitics of representation for nonhuman animals to be seen and show themselves. For all the well-trodden debates about representation, this is a must. A firm contrast will have to be made with human self-representation, since humans have more capacities and autonomy within the symbolic spaces of political claim making, even if these remain lamentably unequal. These mediated forms of self-representation—which can come through images, through words, or in real life—can only be coherent if they remain nonexploitive. (2) We need to show how human societies, especially those in the Western capitalist mold, can be reimagined for the better by differing relations with the nonhumans around them. This may remain within the dialectic of entitlement, which has fueled human history through pharmakological self-benefits, though now it would take into account entities beyond the human. (3) We need to show how nonhuman animals *already* impact and partake in human politics and history—and, even better, demonstrate how they have already been accorded this place in many non-Western

home discipline of art history. Consider this footnote a general call for collaboration.

epistemologies that might serve as a model, without fetishizing these non-Western worldviews as inherently pure or less violent toward nature, since all worldviews have operational constraints.

Imagine an artist, a particularly transgressive one committed to animal rights, who wants to expose the extractive realities of animal exploitation to the public. Having been given a commission from MoMA to show her work in its central atrium, which is often reserved for contemporary art projects, this artist decides to install a fully functioning factory farm. This could be countless pigs, as in Miru Kim's *The Pig That Therefore I Am* (2010), though, rather than documenting a performance with exploited nonhumans in situ, taking the intensive agriculture to the white cube. Or the work could comprise a sea of debeaked chickens futilely pecking at each other in close confinement, as well as small battery cages stacked high atop each other. This factory farm as readymade might also be participatory. Over the course of the installation, the audience could be encouraged to pick up monocrop feed from a postminimalist pile on the floor to throw at the birds. The artist would also include a discursive element in the form of a small, digestible pamphlet detailing recent ethological discoveries about chickens: the odd bird out of avian ethology, chickens have episodic-like memory, show empathy, live within social individuation, show deductive reasoning (even chicks can do basic arithmetic), and see more ranges of colors than human eyes—in short, chickens are as cognitively and emotionally complex as many birds and mammals.[3] Furthermore, as a form of institutional critique, the artist would point to the museum's own restaurant menu, implicating similar and perhaps even more problematic forms of violence toward animal bodies. In this way, our transgressive artist would show in a direct and visceral way the wrongs of our industrial foodways, all while dealienating the lived capacities of the "food animals" caught up in these foodways.

3. See Lori Marino, "Thinking Chickens: A Review of Cognition, Emotion, and Behavior in the Domestic Chicken," *Animal Cognition* 20, no. 2 (2017): 127–47.

It is unclear what aesthetic merit such an installation might hold, but certainly this work would be deeply hypocritical. It would redouble the very activity it hopes to critique. Judging from the Guggenheim scandal in 2017—which admittedly centered around a far more cherished species for most humans, canines—this installation would also be scrapped well before its execution.[4] It only remains viable as a hypothetical (perhaps one day Banksy could do it, echoing Picabia, using a sea of stuffed animal chickens rather than real birds, as he did in his *Silence of the Lambs* [2013], a refurbished slaughterhouse truck). This does not mean that displaying a chicken in a gallery is a priori wrong or unethical, though there are serious constraints and conditions with respect to the type of life chickens represent. We could equally imagine another artist with sympathetic ethological knowledge illegally rescuing some battery hens and providing them temporary sanctuary from slaughter in an art installation. They would have proper shelter and would only appear of their own volition. Crucially, once the work went down, the ultimate destination would be an animal sanctuary. The installation would function as a way station for safety and extended life. This sort of work aside, however, it has to be said that mediating nonhuman self-representation in art is highly fraught when very real and fragile bodies are directly involved and displaced within a white cube for which evolutionary adaptations have provided little preparation.

But then there is nothing keeping yet another artist from coming along and opening an animal sanctuary as a work of art, again counterculling animals from exploitive foodways. Smithson-like, this artist could display nonsites that index this sanctuary. An example of this can be found in D Rosen's practice and their *Idolatry*

4. For a compelling account of this scandal, framing it agonistically between "interpretation-oriented" approaches more permissive of transgression and "production-oriented" approaches more attuned to ethical wrongs, see Ted Nannicelli, "Animals, Ethics, and the Art World," *October* 164 (2018): 113–32.

III (2019): salt lick sculptures formed by goat tongues on a farm sanctuary, which the artist displays in a gallery setting, encouraging humans to touch in turn. Then there are numerous other avenues of mediated self-representations in words, in paint, and, perhaps most potently—since indexicality remains a powerful force of mediated attestation—in photography and moving images. Nick Brandt's photo series *This Empty World* (2018) is an interesting example. The photographer fabricated various sets near the Amboseli National Park, which spans the Kenya–Tanzania border. These include gas stations, bus stations, constructions sites (especially of highway overpasses), burning charcoal production, and dry riverbeds. Once these sets were built and flooded with dramatic nighttime lighting, local communities, including indigenous Maasai people, were invited for a photo shoot. They appear in various group poses of waiting, working, and gathering in long lines staring at glowing portable devices. Afterward, the sets were left empty for local fauna to explore at will, such as elephants, lions, hyenas, rhinoceros, and gazelles. Once they made an appearance, which could take weeks, they would be photographed from the same angle as the human photo shoot, resulting in a composite print of two different moments melded into one—as if human and nonhuman activity took place simultaneously. Here photographic trickery creates impossible scenes of conviviality and mutual precarity in desultory landscapes and industrial impositions. This series is not mere trickery, however, as local communities play themselves in staged self-representation (albeit uneasily performing the role of necropolitically exposed bodies), while the nonhumans involved really did appear of their own volition and curiosity. In light of such work, nothing keeps us from widening, for example, Ariella Aïsha Azoulay's civil contract of photography to include nonhuman claimants as attesting to themselves via indexical images in ways that are distinct from human claimants—and indeed, if we retain the striated but handy concept of species, there will be as many claimants as there are forms of life vulnerable to violence. As long as the human and nonhuman claims are

not in direct opposition to each other, a nature–culture civil contract of photography is eminently possible.[5]

Brandt's staged photographs superimpose human and nonhuman worlds that are already in real proximity with each other on Maasai land, both falling outside political and legal security—one on the neocolonized periphery, the other just outside the Amboseli National Park reserve, which would otherwise offer nominal protection. Both are forced to deal with global economic impositions and environmental degradation. This is something my hypothetical artist using the factory farm as readymade at MoMA neglected to frame, that is, the precarious human communities forced to deal with the fallout of intensive agriculture. Were the artist to somehow pan out from her specific installation toward MoMA's global complicity with the animal–industrial complex (think of Mark Lombardi–like visualizations), we would find an enmeshed global network of slow and fast ecological violence toward certain classed humans living near certain classed species whose living and dead bodies strain the environment. The 2018 flooding from Hurricane Florence in North Carolina made this toxic proximity acutely visible, as manure lagoons seeped everywhere and dead pig bodies bloomed from their confines like dirty pink balloons. The deleterious impacts of these industries on the human world are wide ranging: zoonotic illness (from both Western and non-Western modes of animal confinement and killing, as well as extractive "spillover"), deforestation, species extinction, dead zones, methane, and global warming. Incentives to cease treating nonhuman bodies as equal parts consumable and disposable abound. Using an old Freudian opposition, these incentives would necessitate a mass overriding of the pleasure principle in favor of the reality principle, which in my most pessimistic moments concerning our pleasure-bundled species strikes me as daunting. This would

5. I am referring to Azoulay's important *The Civil Contract of Photography* (New York: Zone Books, 2008).

also entail an overriding of capitalist impulses, though echoing Frederic Jameson's oft-repeated line, it is easier to imagine the end of the world—of which animal exploitation is playing a sizable role—than the end of capitalism. We would need to jam not only the anthropological machine, as Agamben has argued, but also the dialectic of entitlement that is currently somersaulting us toward autoimmune destruction.

There are, however, ways of positively framing the role of nonhuman animals in human society and culture without necessarily guilting the masses into turning on their reality principles. Breakthroughs in ethological knowledge are useful not only in retroactively exposing the capacities of systematically exploited animals. They can also serve to show the ways in which nonhuman minds, bodies, and communities can live alongside and contribute to human well-being. Here the mobilization of ethological knowledge is crucial. Jennifer Wolch's essay "Zoöpolis" makes this claim—in short, that recognizing nonhumans within city and urban planning can reenchant these spaces.[6] The political philosophers Sue Donaldson and Will Kymlicka have taken their cue from Wolch's essay in their *Zoopolis* (2014), an important rethinking of animal rights theory with not just negative but positive rights in mind. This text is a serious advance in animal rights discourse, offering a tripartite frame of consideration through citizenship theory—namely, domesticated animals, who are wholly dependent on human interaction and care, denizen animals, who are only partly dependent on human interaction, and wild animals, whose sovereignty depends on very limited interaction with human communities.[7] This sort of multilayered kinship thinking dislodges an-

6. Jennifer R. Wolch, "Zoöpolis," in *Animal Geographies: Place, Politics, and Identity in the Nature-Culture Borderlands,* ed. Jody Emel, 119–38 (London: Verso, 1998).

7. Sue Donaldson and Will Kymlicka, *Zoopolis: A Political Theory of Animal Rights* (Oxford: Oxford University Press, 2014).

thropocentric dwelling, especially in design and architecture that is reactive to the positive rights of nonhumans.[8]

Intensive animal exploitation cannot be limited to ethical and ecological concerns alone, leaving the question of democratic politics untouched. For this reason, there is another crucial missing step in my hypothetical artist's installation at MoMA: she would need not only to pan outward to reveal global environmental complicities but also to somehow reveal superimpositions of human and nonhuman worlds in order to disclose contact points—contact points that already and inherently affect the political in both beneficial and deleterious ways. In this specific case, she would need to show how animal industries have and continue to alter human political destinies. A prime example can be found in the Brazilian context, home to the largest meat producer in the world, JBS, which has played a key role in Brazil's recent antidemocratic turn and whose historical provenance is colonial and neocolonial.[9] Arguing that the demos includes the multitude of currently loved, abused, and ignored nonhuman bodies—who neither vote directly (though David Wood has argued that they do vote with their bodies[10]) nor use human symbols but nonetheless affect political systems in both psychic and physical infrastructures—is a major task that lies ahead. Eva Meijer's ambitious program in *When Animals Speak: Towards and Interspecies Democracy* (2019) is an important contribution to these debates, employing ethological knowledge to question the operational exclusion of nonhuman life in political philosophy.[11] Western political thought will also finally have to learn some lessons from non-Western politics of expanded conviviality, formerly

8. For wonderful examples, see the Expanded Environment, a nonprofit organization that advocates for multispecies-minded architecture and design: http://www.animalarchitecture.org/.

9. See my "Zoonotic Undemocracy," forthcoming in *October*.

10. David Wood, *Thinking Plant Animal Human: Encounters with Communities of Difference* (Minneapolis: University of Minnesota Press, 2020), 173.

11. Meijer, *When Animals Speak*.

deemed primitive in the long "civilizing mission" of colonialism and imperialism. Echoing a non-Western disposition toward the nonhuman world, Wood claims that we have "advanced when we think of the world not as a container, nor as a collection of things, but rather as a space of significance."[12] This statement is not only anticapitalist (since one does not extract significance but learns from it) but also invokes an ethology of wonder, in which the natural world is no longer a site of experimentation and control but is filled with sundry forms of disparate communiqués.

On September 24, 2020, members of the Lummi Nation, or the Lhaq'temish, which means "people of the sea," traveled to SeaWorld Florida to mark the fiftieth anniversary of the capture of orca Sk'aliCh'elh-tenaut, known to the aquatic theme park's public as Lolita (ecofeminists can rightly have a field day with the literary history of this moniker). She was abducted in 1970 when four years old off the shores of Lummi territory in the Pacific Northwest. The ceremony, which was livestreamed on Zoom and Facebook, is described as a sacred obligation to *qwe'lhol'mechen,* or "our relations under the water," better known colloquially in English by a very different associative timber: "killer whale." The legal and political struggle to return Sk'aliCh'elh-tenaut to her native waters is ongoing, a restitution that is expressly analogized to legal and political struggles of the Lummi themselves. As one of the leaders, Squil-le-he-le (Raynell Zuni), expressed it, "she was taken from her family and her culture when she was just a child, like so many of our children were taken from us and placed in Indian boarding schools."[13] It is only within a Western paradigm of pejorative animalization that this analogy could prove offensive. For the Lummi, as with so many other non-Western ontologies and epistemologies, solidarity with fellow earthling cultures is a positive identification—and an ecopolitical one. Not so long ago, from a Western scientific perspective,

12. Wood, *Thinking Plant Animal Human,* 35.
13. See http://thenaturalhistorymuseum.org/events/standing-in-solidarity-with-skalichelh-tenaut/.

this sort of thing would have been considered primitivist naïveté or laughed at as new age nonsense. Many of us are no longer laughing. And in fact, even from a Darwinian perspective and genomic research, finding kinship in nonhumans is now verifiable, even if non-Western perspectives, and what is pejoratively called "folk psychology" in ethology, did not need to wait for this verification. The Western view of nature is so clearly corrupt that alternatives are no longer deemed escapist or backward. As Heidegger said, science does not think—but orcas and so many other nonhuman animals do.

To see nonhuman animals as part of human politics opens up many interpretive possibilities, what Wood names a "critical hermeneutics of nature," which might steer us away from automatic separation and debasement toward existential solidarity on this planet.[14] Thus, in a work like Yang Fu Dong's powerful six-channel video work *East of Que Village* (2007), set in in rural Hubei, China, we encounter numerous wild or semidomesticated dogs trying to carve out their existence. The resources appear limited, and the interaction with humans is slim, leading to fights and a general sense of bleak desperation. In watching this work, it is all too easy to fall back on a reading of these dogs as vicious ciphers for a Hobbesian reality or a nature inherently red tooth in claw, yet this reduces the dogs to a one-dimensionality that is undercut by some of the gentler scenes in Yang's work—for instance, the young puppy with a damaged back leg who inspects a trip of goats with apprehensive curiosity. The Hobbesian take is also reductively naturalizing, as if only humans have social, economic, political, and historical contexts. These dogs are nonhuman denizens thrown into a twenty-first-century China in an agrarian village largely left behind by a changing global economy, which has affected all its inhabitants, human and nonhuman, if in distinct ways. Araya Rasdjarmrearnsook's work, by contrast, shows hospitality to dogs in installations that lend warmer tones of conviviality. In her *Treachery of the Moon* from 2012 at Documenta 13,

14. Wood, *Thinking Plant Animal Human*, 174.

she sits on a mattress with her two dogs—Bite and Sugar—watching Thai soap operas on a television in a room that is otherwise flooded with projected moving images showing civil unrest and violence in their native Thailand. Here nonhumãns play a therapeutic role of comfort and are inherently part of the domestic-democratic body politic prey to antidemocratic forces—not only in friendship but also in the deeper material entanglements of the body and mental well-being through mutual affectivities and investments.

In a sadly unfinished work, *In March 2016 I went to Israel to search for wolves but only found dogs that think they are cows,* Martin Roth began exploring a different type of ecopolitical investment with dogs, one patently nationalistic: Israeli cowboys in the occupied territory of Golan Heights employing Turkish dogs to protect European cattle from Syrian wolves, which were inadvertently reintroduced when minefields in the military zone between the Syrian and Israeli border de facto cleared away human presence. Here patriotism, militarism, occupation, and agriculture all intertwine in various totemic identifications. Works such as Yang's, Rasdjarmrearnsook's, and Roth's are only the tip of the iceberg when speaking to the prodigious human and nonhuman animal entanglements and investments that condition the democratic body politic. These also include more hidden, subterranean ways in which animal life (and of course plant life) conditions human political existence. Rivane Neuenschwander's work with invertebrates—the likes of snails in *Carta faminta* (Starving Letters; 2000) or ants in her collaboration with Cao Guimarães, *Quarta-Feira de Cinzas/ Epilogue* (2006)—offers compelling examples. If the human–animal divide has become untenable, it follows that as a central node in the history of Western epistemology and ontology, this corrupted binary breaks down numerous other domains and disciplines. This includes the idea that politics are only on the side of the human animal, unaffected by nonhuman animals, who nonetheless condition the democratic body politic in all sorts of ways—and even, as Meijer has argued, hold their own democratic forms of deliberation on their futures, both as collectives and as individuals.

As I have argued throughout this study, the corrupted human–animal divide complicates ethological knowledge that maintains a strict divide between human and nonhuman. This can now be understood as part of the larger project of decolonizing and deimperializing knowledge and worldly relations. Aníbal Quijano argues that the power relations of Western imperialism run on the subject–object divide in its subordination of nature and other peoples, a divide that was foundational for colonial ethnology and anthropology.[15] Western ethology was similarly founded on this asymmetrical relation of power between subject and object, observer and observed, and in the Anthropocene, the residues of imperial ethnography, anthropology, and ethology need to be critiqued in tandem. I hope the steps in this book offer some methodological contributions to this much larger project of decolonizing knowledge. If this last chapter is shorter than the previous, it is for a simple reason. I want it to illuminate possible paths for future work—both multidisciplinary scholarship that reconsiders a past artistic practice through a method of critical political ethology, research that constructively plays the operational constraints of its disciplines, and much-needed contemporary art practices that consider nonhuman animals in ways that go beyond the tired, standard, and default human thinking that has conditioned and corralled animals for so long. From the deconditioning of tired creaturely historical tropes to the speculative daring of stepping into nonhuman minds and perspectives to the solidarities that can be forged in allowing nonhumans a place in the demos, we will be better equipped to take the foundational role of animality on this planet seriously—for all of our sakes.

15. Aníbal Quijano, "Coloniality and Modernity/Rationality," *Cultural Studies* 21, no. 2–3 (2007): 168–78.

Acknowledgments

Thanks to Lynn Turner for her incisive and generous reading of my manuscript, which not only validated its publication but greatly improved it. Some of the seeds for this study were planted in my PhD dissertation, and I'd like to acknowledge my committee: Claire Bishop, Karl Steel, David Joselit, and Dominic Pettman—not only for setting a high bar of scholarship but also for their continued support as I navigate the squid games of academia. I am also indebted to Vinciane Despret, Laurent Dubreuil, and Cary Wolfe, whom I have never met in person but whose writings have had an outsized influence on me, which is clear from this book. A warm thanks to Eric Lundgren and Anne Carter at the University of Minnesota Press for their guidance, for their editorial advice, and for being all-around pleasures to work with.

Thank you to Lise Kjaer and the Department of Art at the City College of New York for letting me teach my Animal Studies and Contemporary Art course during the spring 2021, summer 2020, spring 2020, and summer 2019 terms. This gave me plenty of opportunities to rehearse my arguments. I thank all the students in these classes for their interest in the many topics we discussed. I first taught this course at the Cooper Union for the Advancement of Art and Science in spring 2017. Thanks to William Germano, Raffaele Bedarida, and the select students in that class who were open to its lines of thought. I am grateful to the following people at various

art institutions who pointed me in the right direction and provided access to some of the moving image works discussed in this book: Sydney Fisherman and Cathy Koutsavlis with Marina Abramovic's studio, Athena Christa Holbrook at MoMA, Cecile Panzieri at Sean Kelly Gallery, and Marine Pariente at Marian Goodman Gallery.

I am grateful to the artists Agnieszka Kurant, D Rosen, and David Weber-Krebs for taking the time to discuss their practice with me. This was most helpful. It is with fondness that I think back on the many conversations I was lucky enough to have had with Martin Roth about his work, nonhuman animals, and so much else. He left behind an amazing body of work; Martin's installations and friendship had a great on influence me. Finally, as always, I am indebted to the love and support of my family and my partner, Media Farzin.

(Continued from page iii)

Forerunners: Ideas First

Arnaud Gerspacher is adjunct assistant professor in the art department at the City College of New York.